JUL 87

W9-BRR-118

DRaWinG WiTH YOUR ARTIST'S BRain

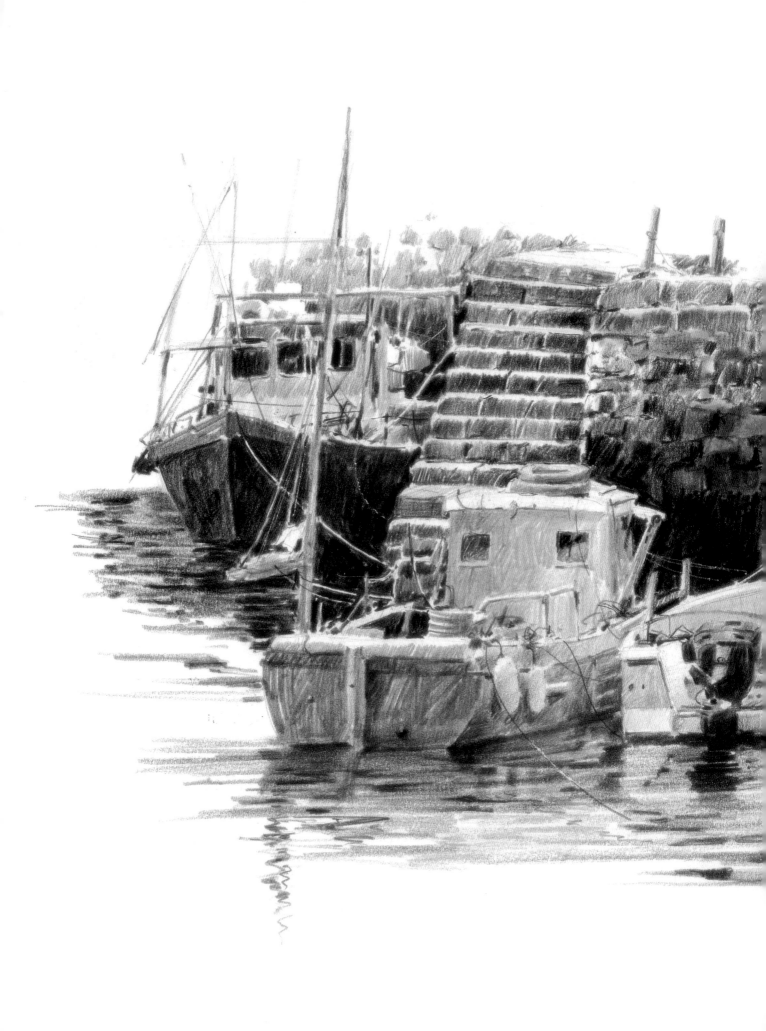

drawing with your ARTIST'S BRAIN

Learn to draw what you see— not what you *think* you see

GLEN ELLYN PUBLIC LIBRARY
400 DUANE STREET
GLEN ELLYN, ILLINOIS 60137

Carl Purcell

NORTH LIGHT BOOKS
CINCINNATI, OHIO
www.artistsnetwork.com

ABOUT THE AUTHOR

Carl Purcell is the author of *Painting With Your Artist's Brain,* a North Light publication with a focus on watercolor. For thirty years, he taught at Snow College in central Utah where he developed the drawing program presently used in the college's art department. He is the recipient of numerous awards and is a popular watercolor and drawing workshop instructor. Mr. Purcell can be found on the web at www.carlpurcell.com. He lives with his wife Nan in the small rural town of Manti, Utah. They have five children.

Drawing With Your Artist's Brain. Copyright © 2007 by Carl Purcell. Manufactured in China. All rights reserved. No part of this book may be reproduced in any form or by any electronic or mechanical means including information storage and retrieval systems without permission in writing from the publisher, except by a reviewer who may quote brief passages in a review. Published by North Light Books, an imprint of F+W Publications, Inc., 4700 East Galbraith Road, Cincinnati, Ohio, 45236. (800) 289-0963. First Edition.

Other fine North Light Books are available from your local bookstore, art supply store or direct from the publisher.

11 10 09 08 07 5 4 3 2 1

DISTRIBUTED IN CANADA BY FRASER DIRECT
100 Armstrong Avenue
Georgetown, ON, Canada L7G 5S4
Tel: (905) 877-4411

DISTRIBUTED IN THE U.K. AND EUROPE BY DAVID & CHARLES
Brunel House, Newton Abbot, Devon, TQ12 4PU, England
Tel: (+44) 1626 323200, Fax: (+44) 1626 323319
Email: postmaster@davidandcharles.co.uk

DISTRIBUTED IN AUSTRALIA BY CAPRICORN LINK
P.O. Box 704, S. Windsor NSW, 2756 Australia
Tel: (02) 4577-3555

Library of Congress Cataloging in Publication Data
Purcell, Carl L. (Carl Lee)
 Drawing with your artist's brain / by Carl Purcell.-- 1st ed.
 p. cm.
 Includes index.
 ISBN-13: 978-158180-811-7 (hardcover : alk. paper)
 ISBN-10: 1-58180-811-9 (hardcover : alk. paper)
 1. Drawing--Technique. 2. Visual Perception. I. Title.
 NC730.P85 2007
 741.2--dc22 2006025949

Edited by Jeffrey Blocksidge and Erin Nevius
Cover designed by Wendy Dunning
Interior designed by Sean Braemer
Production coordinated by Matt Wagner

Metric Conversion Chart

TO CONVERT	TO	MULTIPLY BY
Inches	Centimeters	2.54
Centimeters	Inches	0.4
Feet	Centimeters	30.5
Centimeters	Feet	0.03
Yards	Meters	0.9
Meters	Yards	1.1

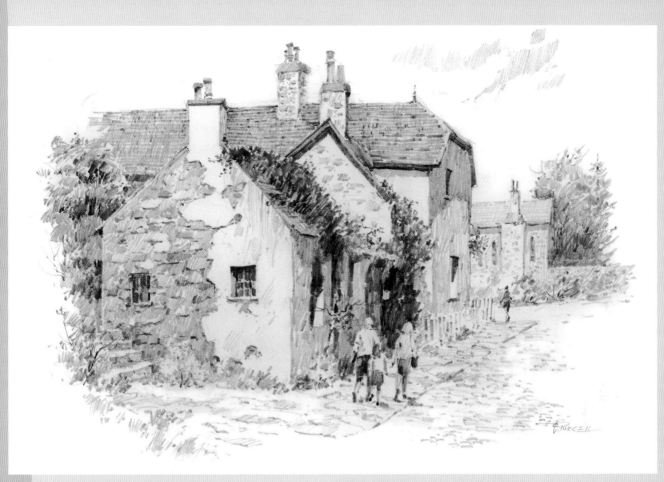

To my five children, Rhodri, RoAnne, Rannoch, Randon and Ranita.

While my own desires in art always seem to be a little beyond my grasp, and while my faith in my abilities hangs on the success or failure of the current piece, their faith in me has never wavered.

ACKNOWLEDGEMENTS

I wish first to thank my wife Nan for all her support and patience. Everyone knows to "ask Nan" if they have questions about my schedule. She is the foundation and framework of the building that is my life. My gratitude to God for the incredible privilege of being an artist and of sharing my joy in life with others through art. I am grateful to the many artists who have influenced me and for the students over the years who have helped me to develop the concepts in this book. And finally, my thanks to my editors Erin Nevius and Jeffrey Blocksidge who were responsible for making sense of my manuscript and for guiding it through to its final state.

Table of Contents

near cleggan
Ireland

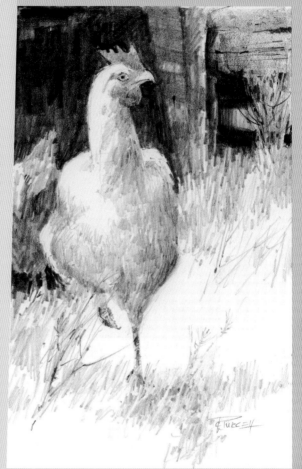

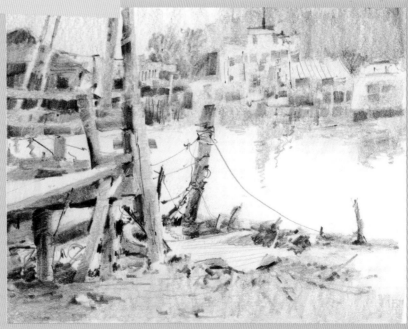

Introduction

If you've always wanted to draw but believed you didn't have the talent, don't give up. The good news is you already possess drawing abilities!

Learning to draw is simply a matter of training—training your brain to apply the functions it uses for other tasks to the specific task of drawing.

The best description of the purpose of drawing I have ever read was made by Frederick Franck in his book *The Zen of Seeing*. He said:

It is in order to really see, to see ever deeper, ever more intensely, hence to be fully aware and alive, that I draw what the Chinese call 'The Ten Thousand Things' around me. Drawing is the discipline by which I constantly rediscover the world.

I have learned that what I have not drawn, I have never really seen, and that when I start drawing an ordinary thing, I realize how extraordinary it is, sheer miracle.

The Purpose of This Book is:

1. To point you to the functions of your brain that make drawing possible.
2. To help you access those functions in the service of drawing.
3. To make you aware of the built-in processes in your brain that hinder your ability to draw.

Once you know what to train, how to train it, and what causes problems, you can learn to draw well. Practice, of course, will make you better and faster at drawing.

When I first began to teach drawing at Snow College in central Utah, I used a program similar to the classes I had attended at the university. The results were terrible! I was only able to help a few students who already drew fairly well.

I reasoned that if I could learn to draw, then anyone could. We teach basic math and writing without expecting students to become mathematicians and novelists. Why couldn't we teach students basic drawing without expecting them all to become artists? People who can draw do not have an extra "talent" node on their brains.

I initiated a seven-year search to discover which functions of the brain artists use when drawing and the causes of the more common problems experienced by my students. I discovered that the right tools for drawing are present in everyone's brains but we have other mental processes that subvert the activity of drawing. I developed a program that made students aware of what was happening in their brains when problems occurred in drawing. I then helped them to develop conscious control of their functioning spatial abilities to make drawing easier.

The results were astounding. Instead of helping a few in the class, I was able to help almost all of them. Everyone was drawing better than my most "talented" students in previous classes. My own drawing skills also improved—an added bonus!

I believe that understanding what's happening in our brains while drawing is the key to developing and controlling the necessary skills and processes that cause many to have problems in drawing.

DRAWING SHOULD BE AND CAN BE FUN!

SALISBURY WALKABOUT
Graphite on bristol paper
11" x 8.5" inches (28cm x 22cm)

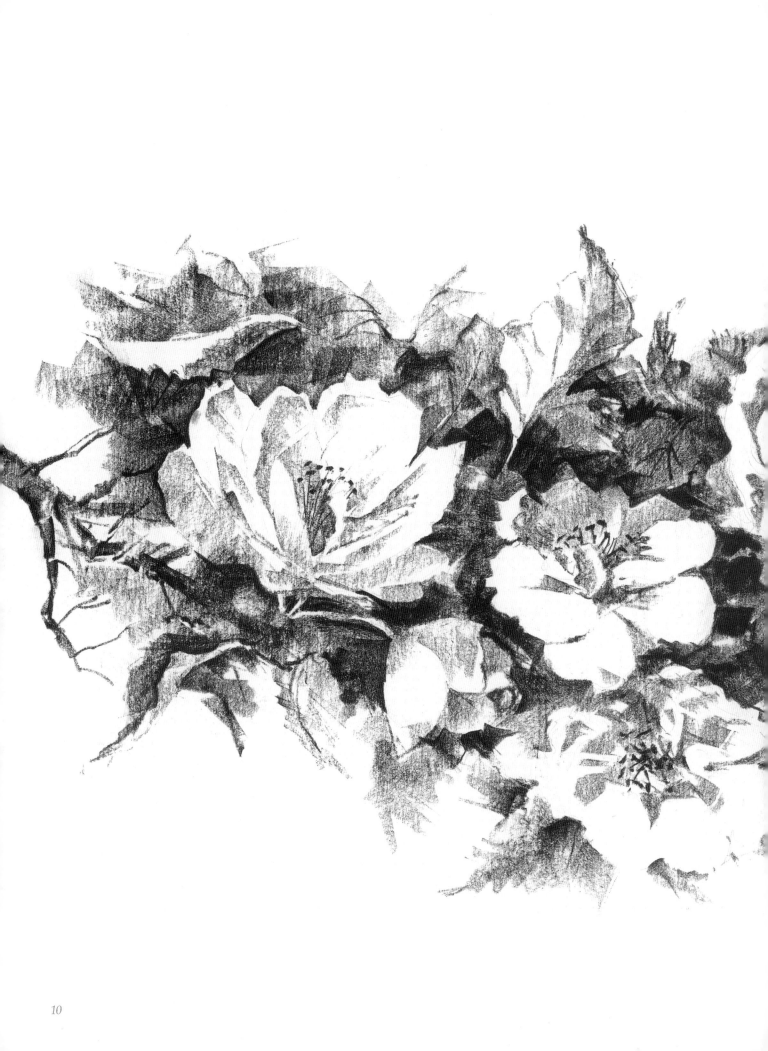

looking into
YOUR BRAIN'S TOOLBOX

APPLE BLOSSOMS
Sanguine Conté on acid-free foamcore board
12" x 15" (30cm x 38cm)

Drawing is fun! Why, then, does drawing seem to be so difficult for most people, even art students? Why should it be? All the information is right in front of you. It's like taking a test with all the answers on the board. Yet for some reason, you struggle to transfer that information to your paper. Drawing shouldn't be a frustrating process for anyone. Let's find out why it so often is.

Like most people, I used to think that learning to draw was simply a matter of developing drawing skills. This is only partly true. Developing these skills requires you to know your problems, and know them well. This chapter will do just that by explaining the sources of the most common problems you will encounter in drawing. You've probably already encountered these problems and considered them as evidence of inability. This is simply not true!

Everyone who attempts drawing must, in one way or another, overcome the problems discussed in this chapter. It may be easier for some more than others. When I was learning, I was in the middle. It wasn't easy, but it was easy enough that I was encouraged to work hard and keep practicing. Knowing what causes your problems will make it easier to overcome them, and you need look no farther for the source of these problems than inside your brain.

If you're frustrated with drawing, it's because you're using the wrong mental tools for the job. Can you see what you want to draw, but when you try to draw what you see, it comes out wrong? This chapter will show you what your own brain is doing wrong and why.

Use the right tool for the job

The Two Information-Processing Tools of Your Brain

Your brain processes visual information entering through your eyes in two distinctly different ways: spatially and intellectually. The first and faster is the spatial process. Its primary function is to keep you informed about the constantly changing space around you by recording where and how big things are. It perceives shapes and spaces, dark and light patterns, vertical and horizontal orientation, size relationships and the relative locations of shapes.

The spatial part of your brain does not identify these as trees, cars and people; that kind of identification comes later. All of this is done on autopilot, just at the threshold of your consciousness. When you parallel park a car or walk through a crowded mall, you use this spatial tool. Its primary job is to navigate you through space safely.

The analytical or intellectual portion of the brain processes the spatial information not as visual images, but as data. When you identify the shapes you are seeing as skirt, blouse, hair, etc., you are using the intellectual brain. This is the right tool for just about every other conscious activity of your life. But when you use this part of your brain to draw, the results are disastrous. It first translates the visual information it has received from the spatial brain into data, then creates a simplified visual symbol to stand for the information.

Keep it Simple
Using verbal-analytical abilities to draw is like using a mop to play golf. A mop is a good tool for cleaning the kitchen floor, but the wrong one for golf.

Know Thy Enemy
Knowing what your intellect will try to do when you start to draw will help arm you for the battle ahead.

There are four ways in which the brain distorts information needed for drawing, thus causing the most common problems.

1. It interjects previously stored data about the object into the activity of drawing.
2. It calls up early symbols created to stand for (not look like) the complex visual information it receives.
3. It creates new symbols and generalizes information to make it easier to store.
4. It focuses on surface details for which it has a name and ignores information that explains the structure of forms.

Know the limits of your intellect

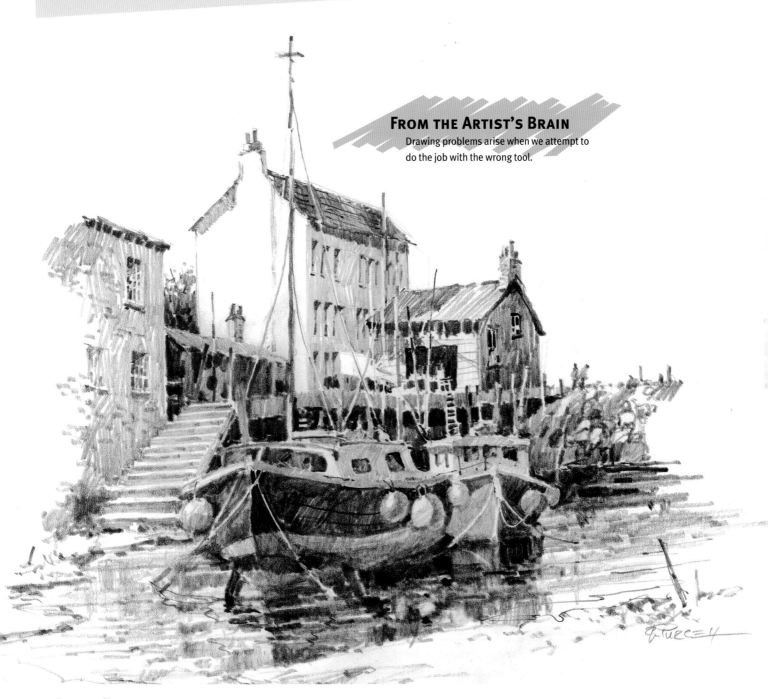

FROM THE ARTIST'S BRAIN
Drawing problems arise when we attempt to do the job with the wrong tool.

POLPERRO HARBOR
Graphite pencil on bristol board, 9" x 10½" (23cm x 27cm)

The intellectual brain imposes previously stored data into the drawing.

This problem is evident when you start to draw a simple object like a box. The conflict between what you know (analytical, intellectual) and what you see (visual, spatial) is very clear.

You want to draw the box, but you're faced with a dilemma. The visual information does not match the intellectual information. Is the object made up of rectangles or of these odd geometric shapes perceived by the visual brain?

The Dilemma
Does trying to resolve the conflict between spatial and intellectual visual processing make you feel like this?

Perspective is Not the Problem
Most people complain that they don't understand perspective and that this lack of knowledge makes it difficult to draw a simple box. It is not lack of knowledge that causes the problem.

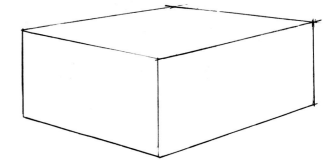

What's Really There
These are the shapes the visual brain records. It sees an object with three planes, each having a different shape. And not one of these shapes has a 90 degree angle!

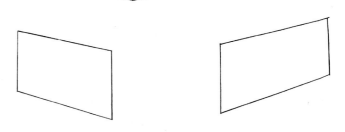

What Your Smarts Say
Your intellect says, "Oh yes, that is a box. I can see three of its planes." And what does it know about those planes? It knows that the planes are composed of rectangles, four-sided geometric shapes with four right angles, especially with adjacent sides of unequal length.

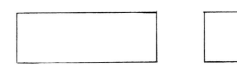

The Answer

Both sets of information are true! One is a visual truth about the shapes as they are seen, and the other is an intellectual truth about what the shapes mean. If you want to build a similar box, measure it and use the intellectual data. If you want to draw it, ignore that data and focus on the shapes you see.

However, since the analytical part of your brain controls the conscious activities of your life, it naturally thinks it should also control the act of drawing. And this is the cause of the problem. You are trying to draw the box, but your brain is sending two conflicting messages. What do you do? Compromise?

Is Compromise Possible?

We're civilized people, can we meet half-way between true visual information and the intellect?

The Sad Truth

Compromises in drawing do not work. This is the kind commonly reached; it contains elements from both bodies of information.

Your analytical brain compromises by admitting that the angles you see are not the 90 degree angles it knows are there, but it is unwilling to find out exactly what they really are. It tells your hand to put in any angle that is somewhat close. Your task in drawing is to turn off the analytical information and focus only on the visual.

FROM THE ARTIST'S BRAIN

For most people, drawing is a fight with the intellect to adjust the drawing bit by bit toward the visual truth of what they see.

Problem 1 in Action

A container with a round opening presents another example of this classic conflict between the visual information supplied by the eyes and the intellectual data supplied by your analytical brain.

I know this mistake is the result of a compromise and not an error of perception: In thirty years of teaching, I've never seen a student observe a narrow elliptical opening and draw an even narrower ellipse. Invariably, students draw the opening wider than they see it. If it were only a mistake in observation, some students would draw a too narrow version of the shape. This was my first clue that something happened to the observed information after it entered the student's brain, distorting it on a consistent basis.

I find that making you aware of the mental conflicts you will encounter makes you look twice before putting pencil to paper. And that second look gives you the information you need in order to draw it right the first time. As a result, you're able to draw faster and more accurately.

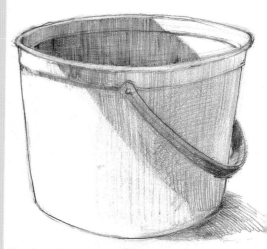

Not Just Boxes
Do you have problems drawing simple containers like this one?

What we see

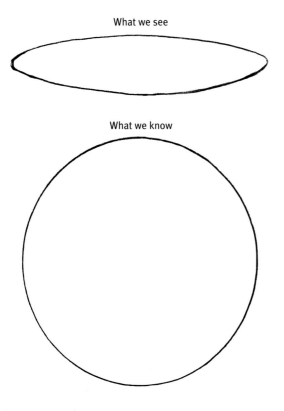

What we know

Seeing vs. Knowing
What we see of any circular opening is a foreshortened view, an elliptical shape. We know it is a circular opening, and we know what a circle looks like.

The compromise drawing of the opening will be somewhere between the narrow ellipse seen and the circle the intellect knows it to be.

Why We Can't Just Get Along
This is what the compromise drawing might look like.

I often saw students do this. Why? At first I chalked it up to mistaken perception, but it happened too often to be the case. Now I know! Their intellectual brains told them that the bottom was flat because it's sitting on a flat surface.

The analytical brain creates symbols intended to stand for (not look like) the visual information before you.

We create symbols for everything. It is a method for compressing large amounts of information into smaller packages. The digit "5" is a symbol for a given quantity. The Yin-Yang symbol stands for a complex cultural concept.

The brain also creates symbols for the things we see, acting as shorthand versions. They are not meant to be a likeness of the item. For example, the common symbol for mountains -^^^- is not meant to resemble a particular mountain, but to stand for all mountains.

For a child, creating symbols is a method of communicating feelings. You will find that children spend much more time creating symbols on blank paper than they will spend with coloring books. The paper gives them a world in which to express themselves. At some point, most people become dissatisfied with these symbols and try to shift towards making their creations appear more like the individual items they see. We call these people artists.

Most people encounter difficulties and give up. For them the intellectual brain (which has received all the attention in school and home) is dominant.

Drawing is based entirely on the visual information supplied by the visual brain. Drawings are the product of intense observation, not intellectual interpretation.

The Symbols We Make

Art That Stands for Something
No child thinks this is how mommy really looks. In fact, when asked they say, "This is Mommy," not, "This is what Mommy looks like."

Building Your Symbol Collection
Between the ages of three and ten we create a host of symbols to represent the things around us. These symbols become more complex as we age, and new symbols are created for all the details.

Problem 2 in Action

In my previous book, *Painting With Your Artist's Brain* (North Light Books, 2004), I used the following example. I often see people who are looking right at a pine tree draw a version of their childhood pine tree symbol. How does this happen?

The intellect is trying to control the drawing process. It recalls the childhood symbol, and it compromises by changing the symbol a little. Intense observation would reveal information about the tree's shape and edges, but this not only takes time, it also puts you in a visual mode that shuts the intellect out. Ouch!

A person sees something like this.

The intellectual brain recalls a childhood symbol for "pine tree."

Seeing this symbol work as well as it did in the third grade, a compromise is reached in which some of the observed features are grafted onto the childhood symbol to create a new symbol.

From Seeing to Remembering

The image in front of a person goes through a transformation from what is *seen* to what is *remembered*, resulting in a disastrous compromise.

The intellectual brain creates new symbols and generalizes for better storage and retrieval.

Accurate drawing requires intense observation. You can assume nothing about the object: Approach with a blank page and the willingness to see it as it really is. That is far different than simplifying and generalizing the information for easy storage. The two tasks are simply not compatible.

There is nothing wrong with the generalizing mode of the intellect. It protects us from sensory overload. We can't go through each day taking note of every little detail. We would soon burn out. So we create broad generalities that do not bother with the specific variations. Roses are red. Bananas are yellow.

Symbol-making is one way of simplifying and generalizing visual information. However, when it insinuates its symbols into the drawing process, a process that requires the recording of specific, unique information, it becomes a problem.

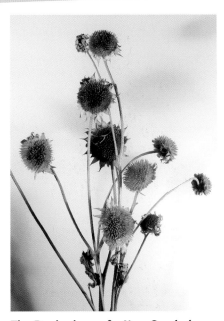

The Beginnings of a New Symbol

When you look at these dried sunflowers, you identify them, store the information in case you have to identify them again, and move on. If asked about their color, they are brown and dark. Period!

However, if I tell you to draw them, your response might be different. "What!" "That's too difficult!" "They're too complex!" To help you, the intellect will create some new symbols to simplify the task. Not so good of a friend!

What Your Intellect Creates

This symbol represents the essential information concerning the dried sunflowers without intense observation. It records the generally prickly nature, the curve of the stems and the fact that there are larger, triangle-shaped objects around their perimeter. This drawing doesn't even mention the leaves. It seeks general information that can stand for all dried sunflowers.

Typically, the analytical brain does not care about the relationship of each flower to the next one or about the peculiar twist in the dried petals or the specific curve of each stem. It simply asks, "Where are they?" and answers, "At the end of curved stems." It seeks a symbol for all petals. Likewise, it creates a symbol to stand for all the prickly centers and selects one curved stem to stand for all stems.

Problem 3 in Action

Doing a drawing that actually looks like these sunflowers will require you to create marks that convey the actual quality of the sunflowers and that you place all the parts in the same spatial relationships that exist in the original forms.

Don't fall into the trap of letting the intellectual brain give you the "Tarzan approach" to your drawing. "Me Tarzan, you Jane!" "Sky blue!" "Grass green!" "Sunflower prickly!" "Stems curved!" You can do a faithful drawing of these sunflowers only if you turn off the symbol-making analytical brain and allow your more artistic, visual brain to handle the job. Your visual brain enjoys the complexities of the image.

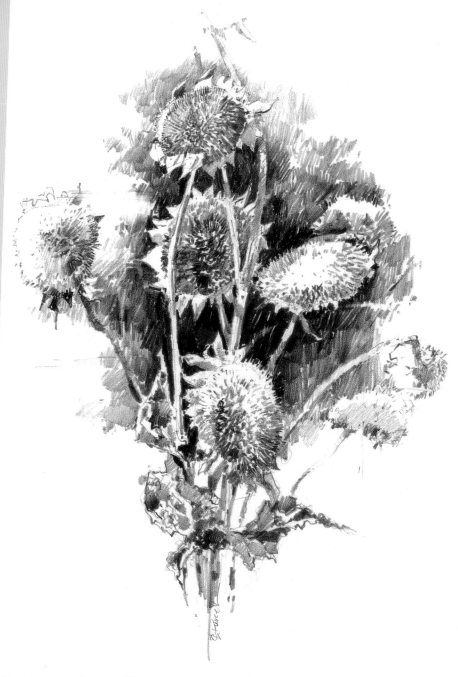

Drawing as a Means of Discovery

This drawing discovers the complexities of the forms, the brittleness of the leaves, the prickly quality of the centers, and the lights and darks as they reveal an edge in some places and dissolve it in others. Unlike the intellectual symbols, this drawing cannot be repeated. Another drawing of the same subject would yield a different result. Even a slightly different view would produce a completely new set of relationships to explore.

SUNFLOWERS
Graphite pencil on bristol paper
9" x 7" (23cm x 18cm)

The analytical brain focuses on the surface details it can identify, ignoring information that explains the form.

A common statement by adults who claim not to be able to draw is "I can't even draw stick figures." That, of course, is not true. What they mean is "I can't make my stick figures look realistic." Well, of course, they can't—people don't look like stick figures!

It's odd that in our culture we assume that everyone can (and should) learn basic language skills although only a small percentage will become authors. We also assume that everyone can learn math while only a few will become mathematicians.

However, we assume that drawing requires some special talent possessed by only a few and the rest need not try.

When I first started teaching drawing, I had no idea where these symbol images came from. Students looked at a subject right in front of them, but their drawings seemed to come from another world. And in a sense, they were. The subject for the drawing was in the visual world, but the symbol that materialized on the paper came from a world of data storage. Drawing ability was over-

shadowed by conscious, symbol-making. Discovering your hidden talent doesn't have to take years.

Drawing well requires you reject to the symbol proposed by your intellect, and ask yourself, "What do I actually see?" There are no shortcuts. The information cannot be generalized or memorized. It must be savored and enjoyed.

Like a good meal, an honest search for visual information in a subject is enjoyable and satisfying. Only your analytical brain thinks it's tedious.

Photo Reference
This gentleman in England was kind enough to allow me to photograph him for a drawing.

The Symbol Drawing
This is a typical symbol approach to drawing a head. Notice the attention placed on nameable details like glasses, lips and hair. But it pays no attention to their shapes. Glasses are glasses; why bother to get the actual shape when a symbol will do? The analytical brain does not notice the hair is dark (shadow) on one side and white on the other. Also, the analytical brain doesn't care about the actual tilt of the head, but includes details like eye lashes although it can't see them. It only knows they are there.

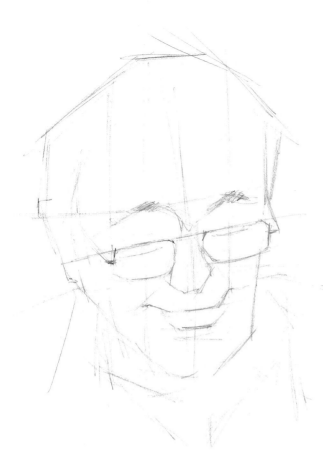

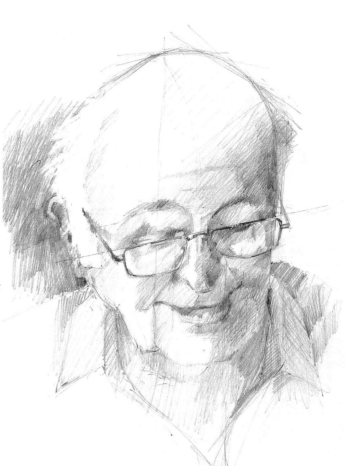

Beginning to See

This, on the other hand, is the beginning of a real search for observational details. Notice the sighting lines that explore the vertical and horizontal relationship of the hairline to the glasses, the eyebrow to the ear.

 This kind of search produces a likeness. The search narrows until it includes the small angles of the shadows around the eyes, the spots of light on the glasses' rims, etc.

An Almost Completed Search

Here the search has progressed to a more complete stage. I would finish this drawing by pushing the values (the lights and darks) and deciding what I wanted to emphasize about him.

POINTS TO REMEMBER

⟶ Your intellect can't draw—it sacrifices all the wonderful information that makes beautiful drawings. It interjects, symbolizes, generalizes and focuses on details. Work around your intellect to see only shapes.

⟶ Pay attention to shadows. When the symbol creation of your analytical brain is unsatisfactory, it tries to remedy the problem by adding details. Its theory is that if there is a problem, more details will solve it. Of course, it focuses on the details for which it has names: eyelashes, stains, bumps, holes, scratches, cracks, warts, wrinkles, etc. It will ignore shadows that explain how the form turns in space.

Problem 4 in Action

This old gas can is a good example of different kinds of detail. It has decorative details that may enhance the visual interest of the piece but do not explain its form. But, it does have structural details that help us understand its form, structure and three-dimensionality. Can you see the difference?

Colorful rust spots. Another detail that the intellect can identify, but which adds nothing to our understanding of the form.

Bullet holes. These are decorative and nameable, but do not add to our understanding of the planes or volume. Your intellect loves these.

The harder edge of the shadow shape at these two points explains the dented surface. The intellect, having no name for this, often ignores it.

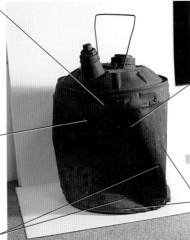

Shadow shapes. This detail is essential to our understanding of the form, the nature of the dented surface and the volume. This is visual information.

The gradual change of values in these two areas tells us that the surface is more rounded. The visual brain sees this and interprets it, but the intellect cannot.

What Makes the Shape?

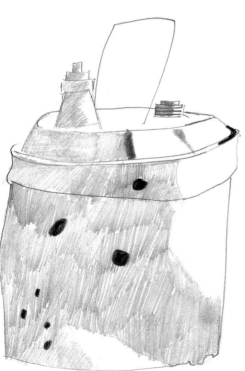

Ignoring Form and Latching onto Details

Look familiar? This is a typical beginner's response to drawing and shading the can. You can tell the intellect controlled the process. Notice the proportions: It's too wide for its height, the spout and lid are too small and too far apart. The bottom is not fully rounded, and the shadowed area is not dark enough. These characteristics were ignored by the intellect as it jumped into the drawing and headed straight for the bullet holes.

Check out those dark bullet holes! You can't help but notice them, can you? Why are they so pronounced? It's because the intellect could identify them and put a name to them. You can almost hear it say "Hey, bullet holes! I can draw those. They're just black dots. That's easy!" It doesn't notice that the holes are only a little darker than the shadowed can.

Drawing Like It Is

In this drawing, I have rendered the shadow almost as dark as the bullet holes. This is the correct value relationship. I have also drawn the height to width and other size relationships correctly. I checked the angles and the positional relationships of the handle, the spout and the lid. A visual likeness is created by these relationships, not by the accumulation of details.

gaining access to
YOUR ARTIST'S BRAIN

Now that you know the causes of your most common problems, you're ready to become acquainted with the abilities in your brain that make drawing easier and more fun. These are abilities you already possess and use every day! You have used them until now on a subconscious level, hardly aware of it. The exercises in this chapter are designed to apply your natural abilities to compare sizes and angles, and to see positional relationships in the act of drawing. Your hand is the physical extension of your mental operations, and as such, can do only what your brain tells it to do. When your brain shifts from naming items to perceiving visual relationships, it will send the information right to your hand. The hand will then record the information in your drawing.

MONTEREY TANGLE
Graphite on bristol paper
9" x 12" (23cm x 30cm)

The drawing tools you possess

There are four mental abilities that you and I possess and use every day of our lives that facilitate the act of drawing. Every artist has a different name for them and trains them whether they realize it or not:

1. The ability to see relationships of angle.
2. The ability to see relationships of size.
3. The ability to see relationships of position in space.
4. The ability to see relationships of value (relative darkness and lightness).

These are not abilities possessed by only a few "gifted" people—everybody uses them all the time. If you focus your attention on searching for these relationships, better drawings happen naturally.

The exercises in this chapter will result in your artistic freedom. Like the study of piano, a disciplined approach to learning the scales and chords that form the structure of all music leads to the freedom to play anything. Similarly, seeing in the right way will create good habits and drawing will becomes easier and more enjoyable.

Isn't it Obvious?
You're already in possession of all the tools you need to draw well.

FROM THE ARTIST'S BRAIN
Remember, you're not gaining new abilities, only putting ones you already possess to use.

WAITING FOR THE FISHING BOATS
Ballpoint pen on bristol paper
6" x 7" (15cm x 18cm)

1 Your Ability To See Angle Relationships

When you straighten a picture on the wall, you are using your ability to compare angles. You look at the edge and compare it to the closest vertical line you can find: the door frame, a window or another picture. When they are parallel, you are satisfied. Lining up pencils and paper parallel on the desk uses this ability. When you parallel park your car, you are matching the angle of your car to the angle of the curb.

Every day in hundreds of ways, you use this spatial ability to see, compare and project angles in space. In most of these instances, you compare an angle with what you know to be vertical or horizontal, for which you have a built-in sense. This is an artistic ability.

2 Your Ability To See Size Relationships

When you pick up a can of beans and open the cupboard to put it away, you look for a space that is at least the same size as the can. Do you measure the can first? Of course not! You mentally memorize its size and scan the shelf for a similarly sized space. When you decide that a parking space is large enough for your car, you don't have to block traffic while you measure both the space and your car. You can look at a drawing of a head and tell if the ears are too big because you are accustomed to seeing a certain size relationship in people. At a glance, you can look at a group of paintings on a wall and tell which is the largest, which is the smallest and which two are hanging the closest to each other. You perform these kinds of size relationship comparisons every day. Now you will consciously use this as a drawing skill.

3 Your Ability To See Positional Relationships

When you describe something as being at "about eye level," you project an imaginary horizontal line in space equal with your eye. Instead of using actual measurements, we often say things like "the dog comes up to my knees." When we read that the man was "standing just to the left of the door and directly below a carved waterspout," we can mentally position him in space.

Maps are simply two-dimensional representations of where cities and towns are located in relation to each other in real space. On a map, vertical represents north and south, and horizontal represents east and west. An essential part of drawing is "mapping" the location of key points in relation to each other. Vertical and horizontal alignments are something we all understand. They are used constantly in drawing.

4 Your Ability To See Value Relationships

We are able to distinguish one shape from another because of variations of light and dark. We also understand volume because of the way light falls on an object. As children, we learned that if a shadow on an object ended sharply, there was a sudden change in plane, and if it changed gradually, the form was rounded. Light and shadow are how we read shape and form, but we do so without thinking. In drawing, you will pay close attention to those changes and how they affect your perception. Recording value relationships is a skill that must be developed.

FROM THE ARTIST'S BRAIN

In drawing, three-dimensionality, depth or volume, all have to do with the same thing: the relationship of value.

Achieving a likeness

To achieve a likeness in drawing, you must use visual solutions. A likeness is only found in correct visual relationships. The only errors possible are as follows:

1. You have drawn an edge or line at the wrong angle.
2. You have drawn a line too short or too long compared to another.
3. You have drawn something in the wrong place in relation to the things around it.
4. You have made the value of an area too light or too dark in relation to its adjacent values.

There isn't a right way to draw noses, a right way to draw eyes and another way to draw trees. Everything in the visual world can only be drawn as shapes on a two-dimensional sheet of paper. You can draw the angle correctly or not, a shape too large or too small, put the shape in the wrong place or draw too light or dark. That's it!

Everything is made up of shapes, and those shapes have a particular configuration because of the relationship of angles, size, position in space, and value. Build a habit

Reference Photo
This gentleman was nice enough to let me photograph him. People expect artists to be a little weird, so you can get away with asking perfect strangers to do this!

Searching for the Visual Relationships
This sketch is a record of a search for relationships. There are no details; everything has been reduced to angles. Curves have been converted to a series of straight lines so the angles can be seen. Sighting lines help locate points on the head that are horizontally or vertically aligned. This search captures the likeness, but no nameable items have been outlined.

Finish with the Values
Here the values have been added and the sighting lines have been mostly covered. The values provide the sense of three-dimensionality, or volume. No amount of shading, however, can correct errors of placement, size or angle. Lavish your time on the first stage of the drawing, not on the details.

AN ENGLISH GENTLEMAN
Graphite pencil on bristol paper
5" x 4" (13cm x 10cm)

of searching for these relationships and you can draw anything.

The following is what such a search looks like.

The Strategy of Search

Our strategy in the remainder of this chapter is to focus attention on three relationships—namely of angle, size and position. Put aside common notions of drawing and replace them with this:

Drawing is a process of searching: It's a search for the spatial and visual relationships of angle, size and position, followed by values. My drawing is the record of my search. The more focused my search, the finer the drawing.

Make a sign of the above statement and hang it where you do your drawing. Remind yourself of it daily. If you stay focused on these relationships, your analytical brain will not be able to intrude. You will discover that drawing is easier and more fun.

One Relationship at a Time
Good drawing habits are a matter of noting a relationship, recording it, then moving on. Even the most complex subjects are handled one relationship at a time.

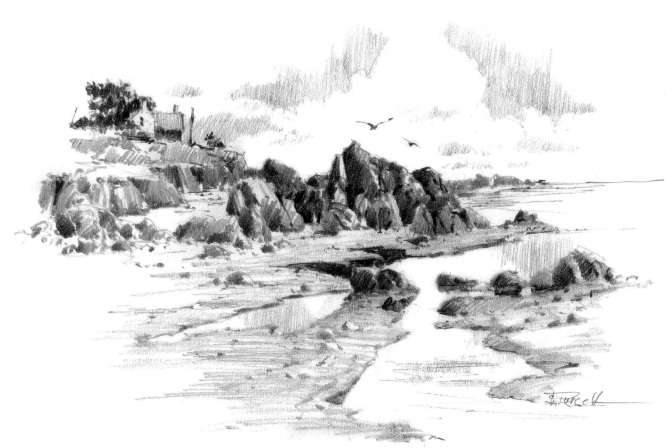

Catch the Spirit
My drawings of the places I visit capture much more of the spirit of the place than the photos I take. I still take my camera along, however, because some things go by too fast.

DORNACH, SCOTLAND
6B graphite pencil on bristol paper
5" x 8" (13cm x 20cm)

Seeing shapes instead of things

Everything in the visual world is made up of irregular shapes that vary in complexity. You don't have to learn to draw shirts, rocks, eyes, etc. You only have to learn to draw shapes. Take comfort in this, for there are millions of different things out there. Anything you draw must be taken just as you see it at that moment, from that vantage point. If you move over one foot, the shape, the angles, the width in relation to the height and the relative position of points in space will change.

How do you get the angles and size relationships right on all these different shapes? One of the most useful tools for checking these relationships is the one in your hand: your pencil.

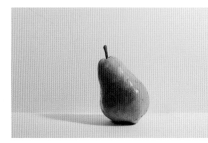

Using Your Pencil to Find Angles

Before you begin to draw this pear, look at it not as fruit, but as a shape. Look at the angles of its edges, the angle of the stem, its height and width and where the stem is in relation to its sides. Use the pencil to check. Prop the book up in front of you.

Seeing Your Subject in Two-Dimensions

Imagine a sheet of glass between you and the subject. If you were to close one eye and draw with a marker on the glass exactly what you see, you would duplicate what you see on your paper—converting three-dimensional material into flat shapes on a flat surface.

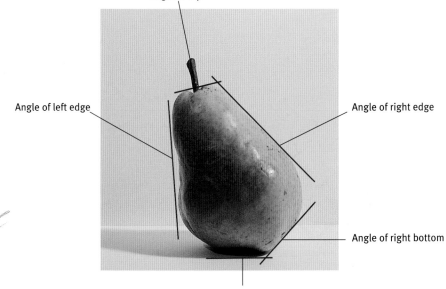

Angle of top

Angle of left edge

Angle of right edge

Angle of right bottom

Angle of bottom

Determining the Angles of the Edges

These are the angles you should see.

Using a Pencil to Measure

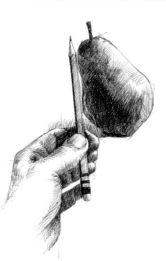

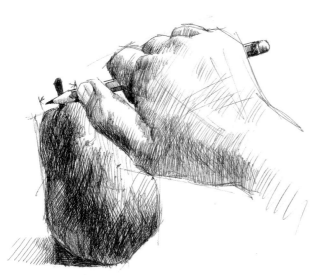

1 Measure the Left Edge
Begin by drawing a line representing the left edge of the pear. Don't worry about the small undulations; focus on the angle of the whole edge. Now hold your pencil out as though placing it flat on a window. Keeping one eye closed, tilt the pencil until it corresponds to the angle of the left edge of the pear. With both eyes, look back and forth from the pencil to the line. The pencil is at the same angle as the edge of the pear.

2 Establish the Size
The size is arbitrary—this first line determines the size of everything else; the rest will be in relation to this line. Mark where the first angle near the top changes direction and at the bottom where it turns.

Next, I usually add an adjacent angle; in this case, the angle along the top edge of the shape. Don't bother with the curve until the proper angle is established. If you establish the direction first, the variations of contour along the angle can be put in with confidence. Look at the angle of the right side of the pear, visualize it already drawn, then draw it. Hold up your pencil along that angle, look at your pencil's angle, look at your line, and adjust it as necessary. The most important thing is angle, size and placement.

3 Find the Size Relationships
When comparing sizes, it's absolutely necessary to keep your arm extended and locked into place. Any change in the distance between your pencil and your eye will invalidate the comparison. Place the tip of your pencil at the point where the angle of the top edge changes direction and curves down toward the left side. Move your thumb along the shaft of the pencil until it is marking the right end of the angle.

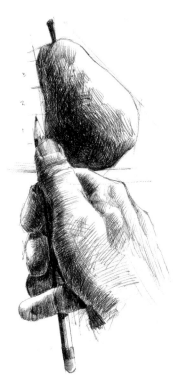

4 Compare Sizes

Keep your arm rigid while your thumb marks the length on your pencil, then rotate your hand until the pencil is parallel with the left side and the tip of your thumb is at the bottom of the first edge you drew. See where the tip of your pencil comes to on the pear. Move your hand and pencil up until the tip of your thumb is at that point. Note where the tip of the pencil comes again and move your thumb up to that point. The length you marked off on the pencil with your thumb is one-third of the first edge.

5 Correct the Size Relationship

Go to your drawing and divide the first line you drew, the one representing the left side, into thirds. You now know the length of the top angle. No matter how long you made that first line, the second line is one third as long. You are using the pencil to get the same size relationship in your drawing—not an actual measurement, but a comparison.

6 Check Sizes and Angles

Use your pencil to see the angle of the right edge of the pear as before. Draw the line, then hold your pencil back up to the subject and repeat the process, looking back and forth from your pencil to your drawn line. When you are satisfied, check its length with the first edge. The first one is a little longer. Make this one a little shorter than your first and go to the angle of the next edge. Compare the widest width with the length of your first edge.

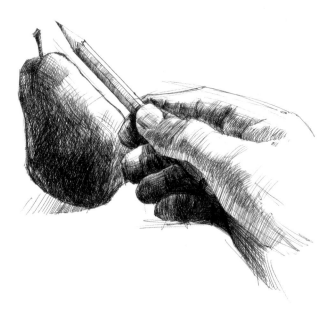

Angle, Edge or Line?

Most of the time in this chapter when I speak about an angle, I will be referring to the angle of an edge on a shape. Your ability to recognize these angle will help you draw every line as it relates vertically or horizontally to the drawing.

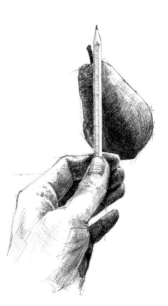

7 Find Positional Relationship

When you complete the shape, your rough drawing contains the essential elements—the proper width to height, the attitude or general tilt of the shape (often called gesture), and the way it sits on the surface. Now let's add the stem.

8 Measure the Stem

Hold your pencil in front of you vertically. Move the pencil over slowly until it touches the right side of the stem. Sight along your pencil to see where that line touches the edge of the shape near the bottom. Mark that point and draw a light line vertically up through the shape. You now have the location of the stem and also know that it leans slightly left from vertical. This time you used the pencil as a plumb line to check vertical alignment. You can also hold it horizontally to sight and find horizontal alignments.

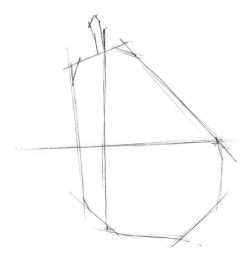

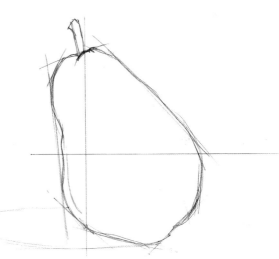

9 Add a Sighting Line

Hold your pencil horizontally and bring it up until it's touching the widest point on the right side of the pear. Sight along the pencil and see what's on the left side. The line goes right through the middle of the first edge. Draw that sighting line; it will be helpful in refining the shape.

10 Refine the Shape

Round out the curves where the general angles meet. Can you see how important the angles are? The curves fall into place if the angles are right. Note the more subtle curves and directions of the contour.

The addition of values will eliminate most of your angle lines and sighting lines. Those that remain are evidence of an honest search and, in most cases, only add to the drawing's integrity.

Strengthening your search muscles

Athletes do push-ups to strengthen their muscles. Likewise, you can do exercises to train your mind to see and respond to these spatial and angular relationships. I've heard it takes twenty-one days to create a new habit. So get ready to exercise. If you practice these exercises once every six months, don't expect much to happen. If you practice them for half an hour each day for twenty-one days, you'll impact your drawing skills forever.

When drawing the edge of a shape, scan the subject quickly for other edges that are the same angle. Parallel lines are the easiest relationships to see. Look at an edge until you see it as an angled line in space, then look around the subject to spot other edges at the same angle.

Let's Get Physical
Like an athlete or musician, you'll only get better at your craft with practice and exercise.

These two edges are at the same angle in space.

Can you find any edges that match the angle of this edge?

Exercise 1: Finding Similar Angles within a Shape.
I have marked two edges that share a similar angle. You may find several. Seeing them develops your search muscles. Practice on magazine photos. Get in the habit of looking for angle relationships. You will eventually spot them immediately.

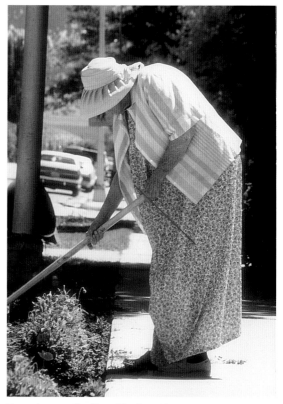

Exercise 2: Finding Similar Sizes
See how many edges and distances you can find in this figure that are the same length as the angle I have marked. I have indicated one to get you started. There are at least eight more. It's best to scan first, then check to verify. This will train you to see these similarities.

Points of Reference

We use points of reference all the time when giving directions. In drawing, the easiest points to locate are in horizontal and vertical relationships. Some artists refer to these as landmarks. They are places where:

1. An edge changes direction
2. Two edges overlap
3. A small but significant object (an eye, for example) is located
4. An object terminates, e.g. the end of a pole or shoe, etc.

When I draw the contours of an object, I bear down a little on the pencil at those intersections to fix them in my mind and make me pause. Then I see where that point is in relation to other fixed points, especially horizontally and vertically.

The easiest size relationship to see is two things of the same size. The length of one edge may be the same as the width of the subject, or the distance between two points may be equal to the length of an edge. Look at yourself in the mirror. Notice that the space between your eyes is the same width as one of your eyes.

The end of her left foot, the tip of the finger on her left hand, and a point half way along the top edge of the shoulder are vertically aligned.

The tip of the hat and the forward edge of her right hand are aligned. That keeps me from putting her hand too far forward or back.

Places the front corner of her sweater, her elbow, and the far right point of her sweater on the same line.

Tells me how far down to place the fingertip on her upper hand.

The fingertip on her right hand is directly across from the bend in her dress.

The tip of her shoe, the point where her sweater overlaps her right arm, and her nose are vertically aligned.

Exercise 3: Finding Horizontal and Vertical Positional Alignments

Compare the photo of the gardening lady with this drawing of her. I have indicated three horizontal and three vertical alignments that were crucial in getting this figure right.

35

Method 1

Comparing Shapes to Find Relationships

To get a likeness of any subject, the edges of the shapes must be at the correct angle, the proportions must be right, and everything must be in the right location (positional relationships). Let's look at four of the most common approaches artists use to apply these rules.

All of the following approaches develop an understanding of the form's inherent structure, eliminate superfluous details and finally use line not as a means of outlining shapes, but to probe and define structural and spatial relationships.

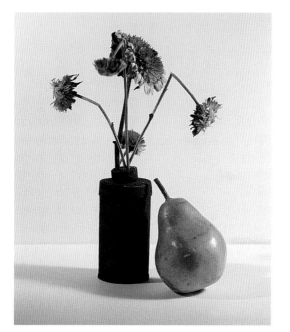

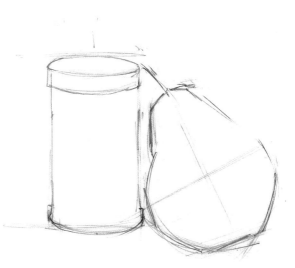

Comparing Shapes to Find Relationships

I set up this still life specifically because all the stems bend at odd angles. Before you follow this demonstration, take a moment to scan the subject for any lines that are at the same angle as each other. See the flower stem at the right and the stem of the pear? Now look at the lower part of that flower stem and notice that the little one at the top is bent the other way but parallel with this one. Is there any part of a stem that is parallel with the edge of the can? Is part of the pear's edge parallel with the edge of the can? If you notice some of these similar angles before you start, you will be ready for them in the drawing. Look for some similar sizes also.

Rough in the Biggest Shapes

It's easier to relate a small shape to a bigger one. So let's start with the two biggest shapes: the can and the pear. Begin the can with two vertical lines. Decide how tall you want to make it, then see how wide it is compared to the height. I found the body of the can to be twice as tall as it is wide.

Where is the top of the pear in relation to the can? The stem is as close to the can as it can be without touching it. Now you can check the length of the pear against the can. Find the width of the pear and you can block in the contours with straight lines.

FROM THE ARTIST'S BRAIN

Every time you draw a line, mark its end point and glance to see if anything you have already drawn is directly across from it, then glance up or down to see if it is directly above or below something. Moving the point at this time is much easier than moving an entire section of the drawing later. This simple check can save many a blunder.

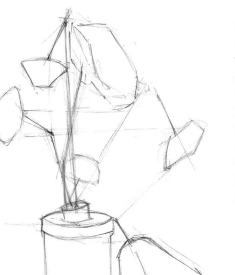

2 Draw Using the Pear's Height and Width

The length of the pear stacked on top of the can (not the lid, just the can) reaches up to a line even with the bottom of the largest flower. The pear at its widest is the same as the length of the largest flower. From the pear, you can get the flower's size and location. As you check positions, put in sighting lines. It will reinforce your good habit.

3 Refine the Edges

Be exact about what happens along their edges. Look at the shapes of the shadows that define the forms. Check the relative widths of the stems and the spaces between them. Add the contours of the pear.

4 Add the Values

Students are always hesitant to put in sighting lines because they are not present in the subject—yet notice how few of them remain. Some became part of the stems, and the axis lines of the pear are completely submerged.

This step only involved putting in values; it didn't involve adding more details. If you want to lavish attention on something, get the exact configuration of the shapes. We will cover value relationships and how to render them in a later chapter.

Method 2

Simplifying, Then Refining Shapes

This has been a standard approach in figure drawing classes for many years. If you have to draw the head as a sphere with attached three-dimensional triangle forms for the nose and jaw, you won't become ensnared by eyelashes and lips. This approach neatly sidesteps the interference of the analytical brain.

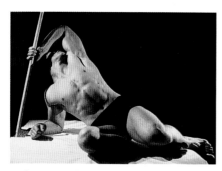

Reference Photo
It's easy to get absorbed in the details and lose the form. I've seen this happen so many times in figure drawing sessions that I believe it to be the norm rather than the exception.

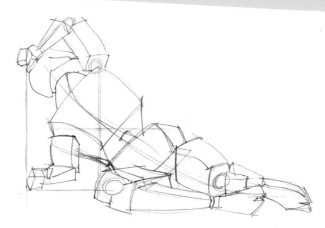

1 Reduce the Figure to Geometric Shapes
Visualize the major portions of the body as geometric shapes that are linked together. By forcing the attention on volume and structure, the details will be ignored. This planar structure is essential if the details on the surface of those planes are to make sense.

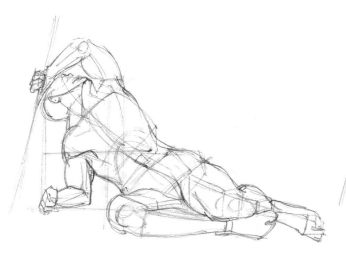

2 Define the Contours
Like the first approach, this method moves from a general statement of form toward a more specific description, introducing the surface details at the very end.

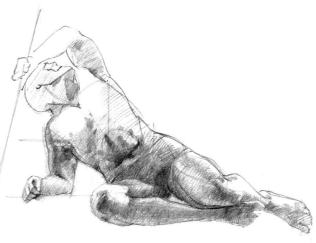

3 Add the Values
Any addition of value, whatever the technique, must be preceded by an understanding of the volume, size relationships, positional relationships and the angles of the forms in space. Anything short of a dedicated search will result in a faulty construction that no amount of shading and surface details will ever resolve.

Method 2: Ellipses

Note that in each case, you will still see the plumb lines and horizontal sighting lines that ensure everything is where it should be.

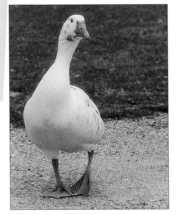

Reference Photo

This goose is an excellent subject to practice converting forms into ellipses and geometric constructions.

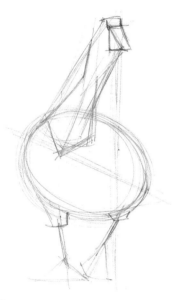

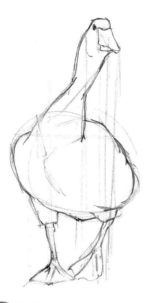

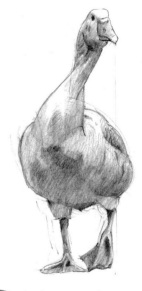

1 Draw the Geometric Shapes

Draw the long axis of the ellipse at the proper angle. Next add the angle of the neck, then break it down into a couple of triangular forms, the top one inverted. Notice how the base of the lower triangle extends down into the ellipse. Add the triangular block that forms the beak and drop a plumb line from its tip to see where the feet are in relation to that point. Finally, the legs can be seen as two angled lines with triangular forms at the ends. Pay attention to where the points of the triangles are in relation to each other.

2 Define the Contours

With the structure analyzed, it's time to pay attention to the contours and to place the eye and get the right angles. Isn't it funny that the goose fits so nicely into the shape of one of its eggs?

3 Check Your Angles

Never stop checking the three big relationships. You can see the vestiges of the initial angles, my pentimento lines. I double-checked the angle by looking closely at the plumb line from the tip of the beak. It comes very close to the outer edge of the left foot. I also dropped a plumb line from the eye and confirmed that the foot should be moved to the right. It pays to check rather than assume.

FROM THE ARTIST'S BRAIN

Like all drawing, this method requires you to look for positional relationships by dropping plumb lines from key locations to ensure that things are vertically aligned. Also, check by sighting along horizontal lines from key points like the hand or shoulder. Do not ignore size relationships. If you don't also search these out, you may analyze the structure of the form but have it in the wrong place at the wrong size.

Method 2: Analysis

It doesn't matter whether you analyze the structure as geometric forms or a group of circles. The important thing is that you begin with such an analysis. Any method that shifts your focus from details to relationships is good. You will find yourself gravitating to the method that suits your personality.

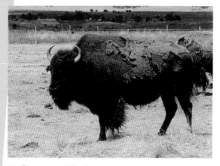

Reference Photo

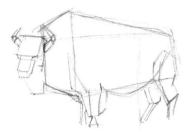

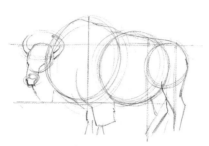

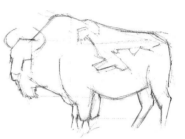

Geometric Blocks
This is an analysis of the form as geometric blocks. It emphasizes the solidity of the forms and the planes.

Overlapping Circles
This approach builds the form upon overlapping circles to represent the major parts of the animal: the hindquarters, the midsection, the massive shoulder and chest area and the head. The legs are added to these basic shapes.

Angular Construction
This is my usual approach, one based on the basic angular construction of the major shape. I see the form as one large shape whose edges are represented with lines at the proper angle, the right length and in the right place.

The Finished Product
This is the final stage of adding the values. Most of the sighting lines have disappeared, but slight vestiges of the angle lines and a couple of sighting lines remain as evidence of the search.

FROM THE ARTIST'S BRAIN
Keep asking yourself the important questions. (And I don't mean "Why am I doing this?") Questions like, "How close is the angle of this object to vertical?" "Are any of the subject's dimensions the same?" "Where is this in relation to that?" Everything is a relationship of size, position or angle. If something looks wrong, the problem and solution lies in one of these relationships.

Method 3

Fitting the Subject into One Shape

All of these methods simplify the subject matter and organize it into manageable parcels. Think of it as similar to creating an outline for a written article. The outline does not present any of the supporting details, but it organizes the main ideas to best support the thesis. Like an outline, these methods organize the task of drawing and present a framework on which to hang the supporting details.

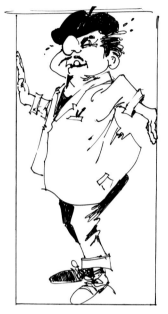

See it Simply
Anything can be made to fit into a simpler shape!

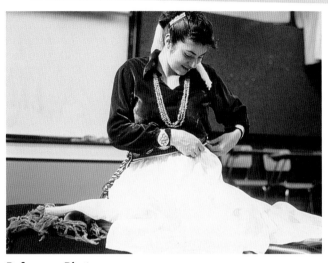

Reference Photo
Sometimes a single figure fits nicely into an easily defined shape. This shape then provides a framework for the whole. Can you see the shape that this figure fits into?

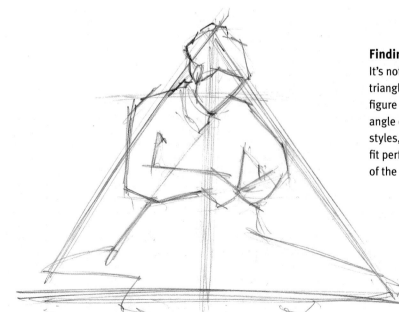

Finding the Shape
It's not often that a figure fits so nicely into an equilateral triangle, as this one does. But be aware, often a complex figure or group of figures fits perfectly into a rectangle, triangle or square. If you are looking at lips, jewelry or hair styles, you will not see these shapes. If some parts don't fit perfectly at this stage, don't worry. At least the majority of the figure is organized for you.

Method 3: Subject as a Triangle

In typical Renaissance tradition this trio formed into a stable triangle shape. We can use that shape to begin our search for important relationships. Raphael would have loved this!

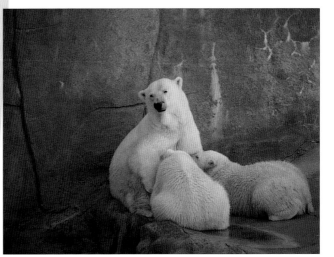

Reference Photo

I was fortunate to be at the zoo one day when a proud polar bear mother was striking a classic madonna and child pose. Except this Madonna had twins.

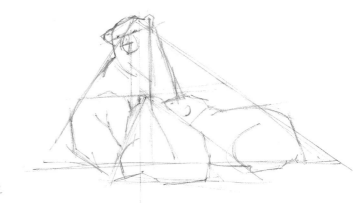

1 Record the Shape

Record the triangle shape that encompasses most of the grouping. This is a scalene triangle, it has no congruent sides.

2 Fit the Figures into the Shapes

Note where each of the figures extends beyond the boundaries of the triangle. If we drop a plumb line from the apex, it passes the cub's ear and touches the ground where his haunches fit over the rock. Draw the angle of the line for the mother's eyes. If you extend the line, it positions the ears. Do you see how the little cub nearest us fits into an almost identical but smaller triangle? Check for similarly angled edges and similar size relationships. All this is part of the search.

3 Add the Values

When you are satisfied that the shapes and angle of the edges are right, and the sizes are correct in relationship to each other, then you can begin adding the values. If any of the above is wrong and you add darker values, it's a lot of work to erase. I promise we will get to values later. Just hang on for now.

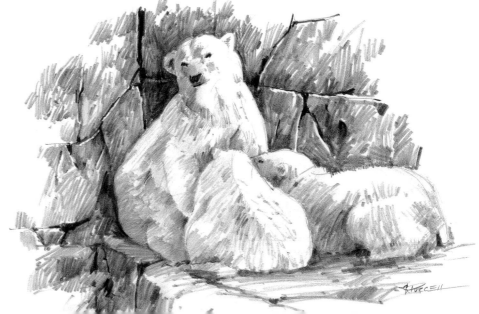

Reference Photo

If you try to draw these lilies petal by petal you will probably get frustrated. I would! Let's simplify the process into more bite-sized steps. See how neatly these blooms fit into a rectangle? Determine its height to width ratio. Hint: the length is one and two thirds times the height. Tilt the right side downward.

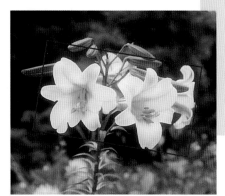

Method 3: Subject as a Rectangle

Remember, these methods are organizational tools. Use them as a framework for your drawings and get a feel for the shapes. Eventually, you won't even notice the details at first.

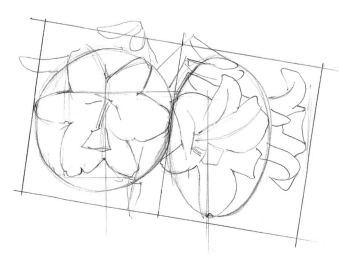

Filling the Rectangle

Now divide the rectangle in half and notice that the left bloom fits into a circle that takes up the first half of the rectangle. The second bloom fits into an ellipse, with the third bloom filling in the remainder of the rectangle's length.

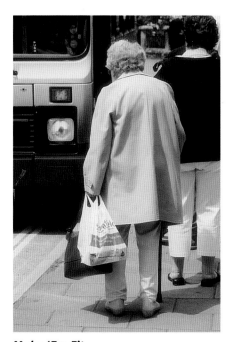

Make 'Em Fit

Visualize this lady fitting into a shape. What does it look like?

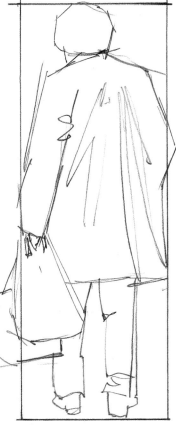

Identifying the Shape

See how well she fits into a rectangle that is just a little over three times as high as it is wide?

A word of caution

One caution I would give in using the first three approaches: Don't look for a magic formula that results in a great drawing every time. You can't memorize a set of relationships because these variables change. You can't memorize, period. Every time we move a fraction of an inch, the relationships of all objects to one another changes.

Some subjects present a general overall shape that make it easier to see the whole. In that case, Method 3 is an ideal way to begin. Other subjects may be more easily mastered by seeing their geometric construction as in Method 2. Some subjects have no overall shape, so you'll need to compare one shape with the others as in Method 1. Become familiar with all the methods in case the need arises, which it will.

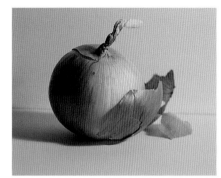

Use What You've Got
All around your own home, there are hundreds of wonderful things you can use to practice drawing skills. Try a pair of scissors, a tape dispenser, the telephone, a paper bag and don't neglect the refrigerator. This onion is perfect!

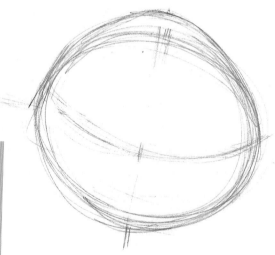

Why All These Steps?
After years of drawing, I asked myself, "If I can draw a shape generally, then adjust it until it is correct, why can't I just draw it right the first time and skip the general stage?" I tried and it worked.

My wife gave me a wonderful Christmas present a couple of years ago. It was the book *Alla Prima* by the great oil painter Richard Schmid. He had come to the same conclusion. He writes, "If I could see the colors and shapes of a subject well enough to correct them, then I could also get them right the first time, and thus eliminate the almost-right stage! All I had to do was be very picky about how I looked at my subject, and what went on my canvas."

However, this accuracy from the get-go requires discipline—assume nothing about the subject.

1 Get the General Shape
This subject has a circular shape that will help us if we get it correct. But before you draw the circle, determine if it's a full circle, more elliptical, straight or tilted. Then draw it, but not with a dark line pressed deeply into the paper. Hold the pencil lightly, and with a full arm movement, lightly block in the shape. I go around a number of times until it evolves into the shape I want. This circle is about as wide as it is tall, and its axis is tilted to the right. It is more like an ellipse with a little added to the top.

Notice that the angle of the stem and these two edges are the same.

Vertical sighting lines help get the placement of the end of the stem and the other shapes right.

If you can get these four points right, you will have placed quite a few shapes correctly.

This shape's top edge was actually the onion's midpoint, so I moved it up.

The top angle of the stem and the angle of this edge are the same. Can you find others?

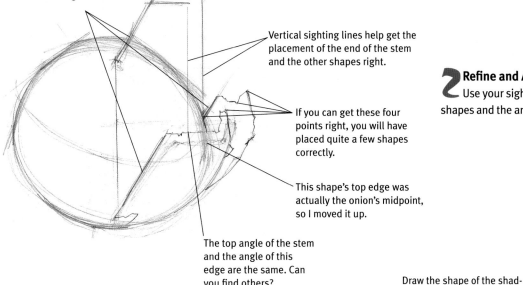

Refine and Add Other Shapes
Use your sighting lines to place the shapes and the angles of the stem.

Draw the shape of the shadows on the stem to explain the twisting of the form.

These lines also explain the contoured curve of the form.

This onion has surface lines that also explain the roundness of the form.

Add Edge Details and Structural Lines
Look at the edges of the shapes. There is no substitute for real observation. Now is the time to correct any errors of placement or angle.

Lightly indicate the shape of this core shadow.

These notches in the edge of the peeling help depict the brittle skin.

If we continued the angle of this edge, where would it strike another point or edge?

Place the Values
Even with the values added, the shapes are what really matter. How dark is one shape in relation to another? What is the actual shape of the shadow? Does it end abruptly or gradually? Think shape!

Method 4

Drawing Adjacent Shapes

You may want to try this last method after you have mastered drawing shapes. It requires you to begin with one shape correctly drawn then move to an adjacent shape, draw it correctly, and so on until the last shape is drawn. It's like putting a puzzle together piece-by-piece.

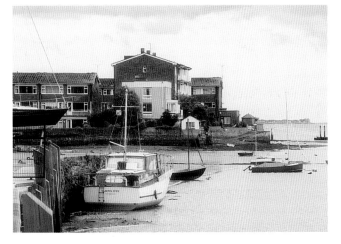

Reference Photo

The temptation would be to start with the boat. But look again— the boat is not an easy shape to see. It's made up of many little shapes, and your intellect will try to insert information about lengths and proportions. The near end of the dark building at the top is a better place to start. That's a shape even I can handle.

1 Get One Shape Down Right

Visualize the completed drawing on your paper. Place the all-important first shape somewhere near the top. Draw the right edge of the shape the size you want it. This is the easiest line in the drawing because you get to decide how long it will be, and the angle is vertical. Measure on the photograph and you will see that three more of those lengths will take you to the bottom of the boat.

Check the length of the edge of the roof. If you don't count the part that sticks beyond the edge of the wall, it's the same length as the first line. The width of the shape is a little more than twice the length of the edge.

2 Proceed to the Adjacent Shapes

Take each shape and relate its size and position to the first shape. If you check, you will usually find that a size repeats. The height of the gray building minus its white cap is the same length as the first line drawn and the roof angle, as is the length of the roof ridge and the height of the right edge.

When you put your pencil point on the paper, pause to see if you are in the right place. You wouldn't swing a hammer and then check to see where the nail is.

Finish the Buildings

Each shape has to be seen in relation to every other shape, whether drawing a scene or a portrait. Also, each shape has its own specific dimensions and configurations. Don't guess! Drawing from life is about accurate observation.

Build the Foreground

The very first line you drew will help you to position the large boat and get its size correct. And the width of that first shape will give you the size. No guesswork!

Also, decide what not to include. The apartment building isn't needed. Lower the connecting building, extend it a bit, then drop it into some trees. The shape of the land will expand as it moves into the picture.

Finish the Drawing

Keep thinking shape: How does the major dark shape of land end? Can you make it better? If you include people, it always adds interest to a landscape.

Look for any flaws in the composition. Your eye movement along the upper buildings toward the right side is checked and re-directed downward by the mast of the small boat. The post and ground pick up that downward movement and direct it back to the left toward the large boat.

BUDLEIGH SALTERTON HARBOR
6B graphite pencil on bristol paper
8½" x 10" (22cm x 25cm)

POINTS TO REMEMBER

┈┈> Visualize the subject as a drawing. You don't have to see all the details, but translate it from an object into a drawing. What will it look like?

┈┈> Ask critical questions to help you draw well: Is there a general, overall shape that will help me relate all the parts? Are there any edges or lines that are parallel? At what angle? What is the general attitude of the subject? Is it vertical or tilted at an angle? If so, what angle? Are there any key points directly across from each other? What is the vertical alignment?

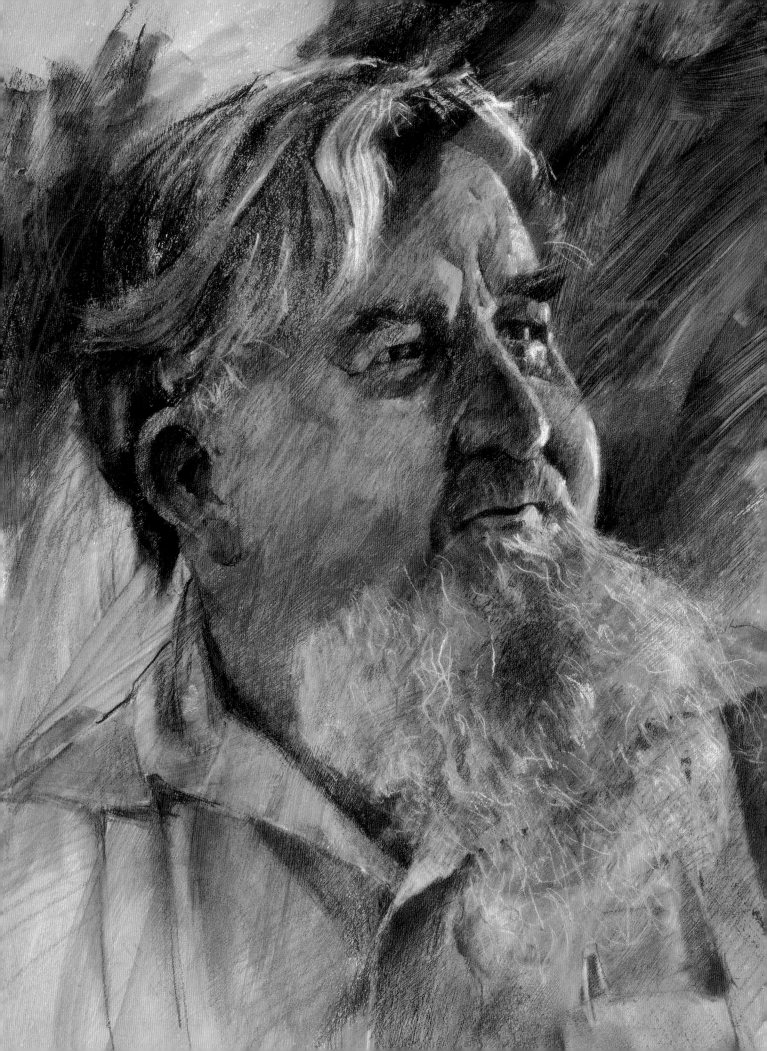

CHAPTER 3

searching for
Line and FORM

The process of search is the same for every subject. Like many people, you may have avoided some subjects because they seemed too complex. However, the search required to draw a pear accurately is the same as the search to draw the human figure accurately. Develop the habit of searching for relationships of angle, size and position and your progress will amaze you.

At this point, we need to say something about the edges or contours of forms and the quality of line we use to define these them. Complex forms provide us with overlapping edges that make the form appear to turn in space. As we refine the search for relationships, we will want to firmly state these overlapping edges through contoured lines. This chapter introduces the contour line as an expressive tool for defining edges and eventually applies this to the complex form of the human figure.

Remember that all forms are made up of simple shapes. Complex forms just have more shapes. When drawing these forms, the journey may be longer, but you can still only travel one segment at a time. Drawing the contour lines of these forms is a decision to slow down and savor the scenery.

ED
Acrylic, Conté crayon & pastel
17" x 13" (43cm x 33cm)

Contour line drawing

The Essence of Line

In nature we don't see lines, only edges of forms. Line is the convention artists use to describe these edges on a two-dimensional surface. But apart from its role in describing edges, the line has character of its own. It can be bold or delicate, energetic or graceful. Lines can be very expressive, both of the subject being drawn and of the person drawing.

Most people starting out in art are not sure of themselves and timid about the lines they put down.

Knowing they are going to make mistakes, they minimize errors by only committing to short line segments. The result is that sketchy line so common in beginning drawings. If drawing a fur ball, this line would actually be effective, but when drawing solid objects with clearly defined edges, these lines look hesitant and timid. Practicing contour line drawing will develop drawing confidence, allowing your lines to be deliberate and correct, even beautiful.

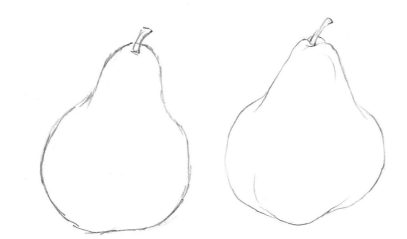

Be Confident

Even if the shape is accurate, as it is in the first pear, the lines say more about the artist's hesitation than they do about the edge of the object. In the second drawing the lines define the contours of the pear and suggest the fullness of its form. In addition, each line looks deliberate, as if placed exactly where intended. Even if the shape is a bit inaccurate, we assume it is right because of the sureness of the lines.

Express Mood and Energy

Pay attention to the energy behind each stroke. The top lines convey a flowing, graceful movement. The second row is more explosive, like a bolt of electricity. You cannot make lines like this carefully. The third row combines delicate and bold lines. Imagine the variety of subjects these different lines can express.

What is Contour?

Contour moves with the edge of a form, defining where a plane changes direction, or where one part overlaps another. It's not confined solely to the edge where shape meets space, but often moves into the interior of the form. An outline, however, is the outside edge of a form, the edge that would be defined in a silhouette.

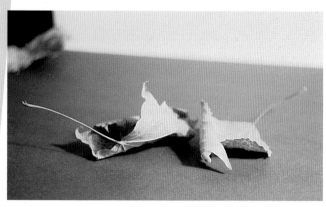

Reference Photo

Organic shapes like this are excellent subjects for contour line drawing because they have edges or contours that overlap and move from the outer edge into the interior.

Silhouette

A silhouette defines where the entire form meets space.

Outline

Like the silhouette, outline only defines the outside edge of the form.

Contour Line

The contour lines here follow the edges of the forms as they move through space. These lines are sharp and crisp, just like the brittle edges of the leaves.

Point-to-point contour

Contour line drawing is a slower, more deliberate kind of drawing that emphasizes hand-eye coordination and empathy with the drawn forms.

My preferred method is called point-to-point contour. First, place the tip of your pencil at a given point on your paper where a contour will begin. Then, look at the subject to determine the point where the contour changes direction or overlaps another contour.

Picture that point on your paper, then pull the pencil line along the contour, matching each bump and change with a corresponding shift in the line. Pause when you reach the point. With the pencil still in contact with the paper, find the next point and continue the contour. Lift your pencil only when you reach the end of a contour. Find the beginning of the next contour and do the same.

Exercise: Pulling a Line

Tape down a piece of paper so it won't move. Place a number of random dots on the page. Then, using a 4B or 6B pencil held between thumb and forefinger, pull a line between two of the dots, pause, locate the next point and pull the line to that point. Try varying the line between points by twisting the pencil as it moves, or changing the pressure. Don't hold the pencil as if you were writing. Writing is composed of short lines created by the movement of the fingers. You want longer, more fluid lines created by the movement of your whole arm. Draw from the shoulder.

Practice your Line

Emphasize the point of directional change with a slightly heavier pressure. You are striving for beauty of line. Use your arm instead of your fingertips. You use your whole body when you dance, not just your feet. The same is true here. Practice pulling lines with sudden changes in line density as shown here on the left. Discover the line varieties that are possible by twisting the pencil, laying it down to pull sideways, and pressing down to pull up the tip.

A number of subjects are good for contour drawing. Organic objects usually provide a lot of contours and make an interesting drawing. However, don't overlook your household items. Eggbeaters, tools, and toys make excellent subjects, as well as figures, twisted wood and old shoes.

Draw a Variety of Subjects

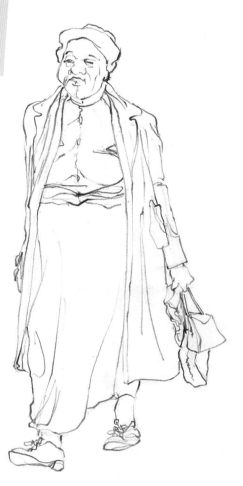

Challenge Yourself
Subjects like this twisted piece of wood are excellent because contours emerge only to disappear behind other contours. Outside edges become inside contours. Some outside contours move through the form and emerge on the opposite side.

Using Line to Explain the Form
This drawing emphasizes the contours of the twisted wood and is complete without the addition of values. The line alone explains the turning of form in space.

Folds of Fabric
Clothing makes an excellent subject for contour line studies because, like the twisted wood, it feature edges that begin in the interior, move to the exterior, then disappear behind another contour.

POINTS TO REMEMBER

- Be confident.
- Imagine your pencil point is in contact with the contour of the subject.
- Go slow. Don't let your eye get ahead of your line.
- Let the movement come from your arm.
- Do not lift the pencil until you have reached the end of a contour.
- Between points, look only at the subject. Don't watch your pencil draw the line.
- Erasing intensifies error. Draw the line again if you want, without erasing.

Capturing an Edge With Contour Line

There are two ways to define the edge of any form: with value changes or with line. Whenever you create a drawing that utilizes both line and value, you will have to decide which will be dominant. I am primarily a value artist, but I love the beautiful line work of such masters as Rico Lebrun and Hokusai. I utilize contour drawing in two instances: I use it to define some of the edges where figure and ground are the same value and when I don't have time for a complete value drawing of a scene—in which case, I do a contour line drawing of all the shapes involved and fill in the values later. The most difficult part is knowing when to stop. I could use someone to snatch my pencil away.

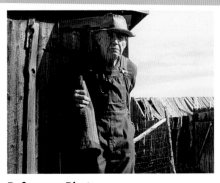

Reference Photo
I like the way shapes of shadow define Alma Larson's face and hand.

The edge of the light shape here defines the structure of his cheek. It's not arbitrary.

Each turn of the shape's edge reveals a different aspect of the form—a depression, a protruding chin, etc.

The overalls are defined by unique shadow shapes.

Each finger has a different shape of light defining it.

Define the Shapes

After the initial search for relationships, my first use of contour line is to define (lightly) the shapes that will be left as white paper. Instead of drawing eyes, nose, mouth and fingers, draw the shapes of light value. If you have trouble seeing them, squint until you see only the shapes of value. Draw those shapes slowly with a deliberate line. Be careful to note each turn and undulation in the edge.

Define the light edge of the hat with some dark in the background.

Merge the dark figure and the dark background in a single value. If you define this edge, you rob the viewer of figuring it out.

Lose the edge of the hat here as it merges with the light.

These lines along the shoulder were pulled with a 6B pencil.

One careful line can give all the necessary information about the zipper flap.

Put in the gray, leave the light shapes.

Carve out the lights by placing darks next to them.

The pencil can be alternately dragged sideways to produce broad lines, then lifted for more delicate lines.

Start near the center of interest—his face. Define a few contours with deliberate, carefully pulled lines.

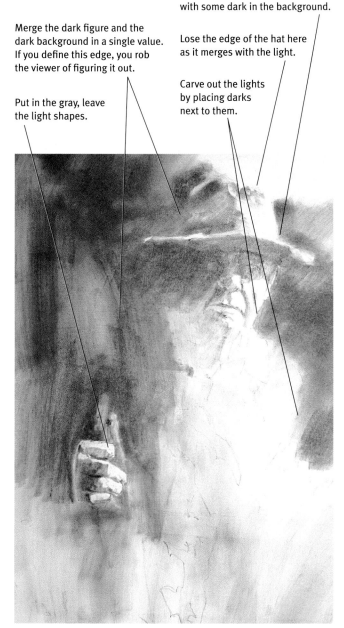

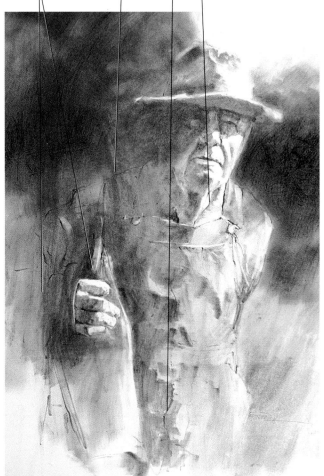

2 Lay in the Values and Define the Edges
The idea here is to have the figure emerge from the dark shadows behind him. Put in the value and let the light shapes pop out. Apply powdered graphite using a piece of thick piano felt as a brush. Lay in the background dark and carry it across and into the figure. It does not have to be recognizable, just dark. Don't let the photo tell you what to do. Define the intricate edges with a blending stump. Lift out small pieces of light such as the edge of the hat brim and the brass button with a kneaded eraser. Some edges will be lost.

3 Select Areas to be Defined
Too much contour line would ruin this drawing. To keep the dominance on value contrasts, carefully select the areas to be defined by line. Resist the temptation to define everything. Leave in lost edges, choosing the contours that best describe the form.

ALMA LARSON
Powdered graphite and graphite pencil
16" x 12" (41cm x 30cm)

Capturing a Figure

When I ask workshop classes what their most challenging subject is, the most common answer by far is "people." As children, we developed an extensive repertoire of symbols about people. Later, when we attempted to draw them, the symbols were substituted in place of observation. Even though we are very familiar with the figure, we never had to create one. In order to reconstruct it, we need to forget about the hair, nose, etc., and focus on shapes and their relationships.

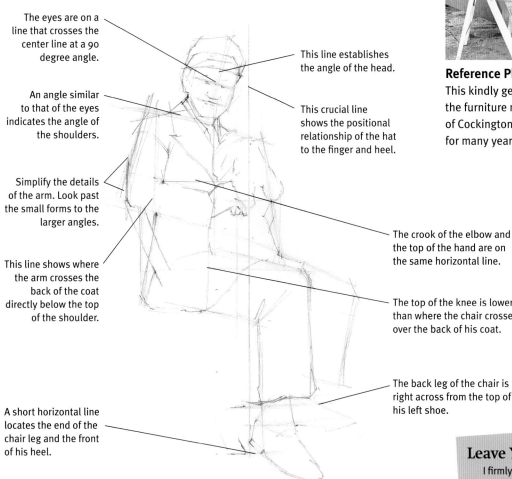

The eyes are on a line that crosses the center line at a 90 degree angle.

An angle similar to that of the eyes indicates the angle of the shoulders.

Simplify the details of the arm. Look past the small forms to the larger angles.

This line shows where the arm crosses the back of the coat directly below the top of the shoulder.

A short horizontal line locates the end of the chair leg and the front of his heel.

This line establishes the angle of the head.

This crucial line shows the positional relationship of the hat to the finger and heel.

The crook of the elbow and the top of the hand are on the same horizontal line.

The top of the knee is lower than where the chair crosses over the back of his coat.

The back leg of the chair is right across from the top of his left shoe.

Reference Photo
This kindly gentleman had been the furniture maker at the estate of Cockington Village in England for many years.

Begin Your Search

Begin your search with a simple vertical line. This gives you the correct tilt of the head (it's an angle relationship to your vertical line). Follow with lines for the angles of the eyes and mouth. Then set up the width and height of the head, which will become the size comparison for everything else. (The heel of his shoe and the bottom of the chair are four head-lengths down from his face.)

This stage in the search is about getting the right tilt or angle to the shapes, locating landmark points and getting the correct sizes. It is not about eyeballs, wrinkles and such.

Leave Your Mark

I firmly believe that a drawing should look like a drawing. If I want a photograph, I will take one with my camera.

Drawings go beyond photographs, capturing not only a likeness, but also the response of the artist to the subject. It is that intangible bit of the artist in the work that makes it art and gives it life. In the end, the art stands apart from what the subject was.

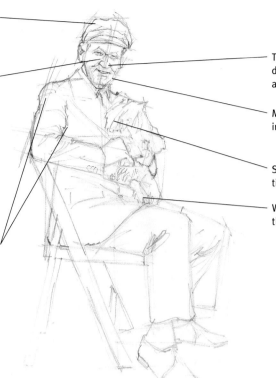

Break down the angles into the correct texture of the edges.

The dots show where the eyes are. Look at the exact shapes. What is the shape of the eyebrow? What are the eye shapes? How do they differ?

Break up the angles of the arm into smaller shapes of the folds.

The shadow shape on the side of the nose defines the planes. How steep are the nostril angles?

Mark the corners of the mouth. Where are they in relation to the eyes? What is its exact shape?

Squint to see the light on the dog. Don't get tied up in the fur. Get the shape right.

What is the shape that defines the dog's leg? If these shapes are right, the dog will materialize.

Refine the Shapes

This second step is like the first: a search for the relationships of shapes. The only difference is now you narrow the search to smaller shapes within the large shapes you developed in step one. The emphasis is not on final appearance but on drawing shapes at the right size, set at the right angle and in the right place.

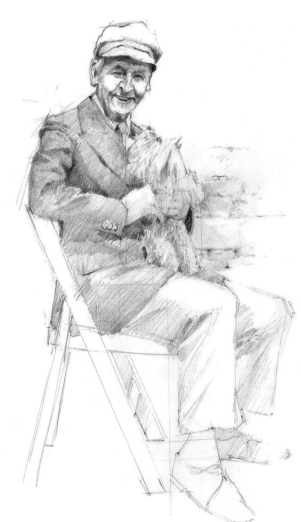

The Final Stage

Focus on what the drawing is about—the man's face and the dog looking up at him. Make certain that the values in these areas are right. As you move further from this focal area, ask yourself if certain shapes need more detail to make the drawing complete, and if not, don't add them. Notice how the shoes were left almost as they were first laid out.

You may want to add a suggestion of the stone wall. It gives a sense of space and location and a value contrast for the light area of the dog. Leave the sighting lines—they are part of the process. A drawing has its own life. In the end, it has to live as a drawing, not as a copy of the subject. These lines are a personal part of the artist's response and are as much a part of the drawing as anything.

THE FURNITURE MAKER
Graphite pencil on bristol paper
12" x 9" (30cm x 23cm)

Drawing a Portrait

Discipline yourself to conduct an honest and thorough search for these relationships and no subject will be beyond you. You will be free to draw anything.

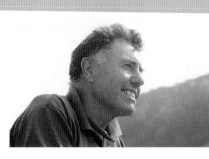

Reference Photo
In England, we took a small boat ride from the pier in Dartmouth Harbour to the castle at the harbor's mouth. This man was the boat's captain.

1 Complete the Initial Search
Begin with a curved line indicating the line through the center of his forehead and curving down to his chin. Use a second line to find the angle from one eye to the other. Establish the relationship of his chin, the bridge of his nose and where his forehead meets his hairline with a third line.

Describe the hair's shape by its edges with straight lines at the proper angles. Note the points of directional change. The uppermost point is above the outer corner of the eye, and the back point is across from where his hair meets his forehead.

Mark the center of the eye to the hairline. This distance repeats itself numerous times.

Draw a line through the eyes to determine where they are in relation to each other.

This line shows the tilt of his head and his general attitude—a lot for one line.

Draw a vertical line up from his chin. It passes halfway between the bridge of his nose and the corner of his eye.

Locate the point where his collar meets his hair across from the top of his lip.

Get the ear shape, especially the location of the ear lobe relative to the top of the ear.

Nail down additional landmarks like the outer corner of the eye, where the neck meets the jaw and the bottom of the ear.

2 Refine the Search
Refine as needed, but don't define small characteristics like teeth, the iris, etc. Resist the urge to get into details. They call to you so seductively: "Oh, look at me, I am so beautiful. Please put me in your drawing." Ignore them! Focus on the search.

Establish key angles such as the angle of the far cheek, under the chin, the neck and the hair.

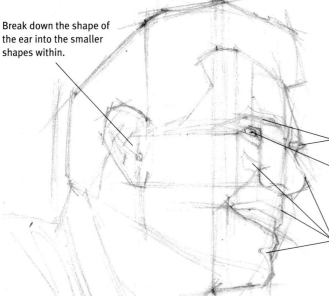

Break down the shape of the ear into the smaller shapes within.

3 Complete Your Search

This is still not the time to get involved with wrinkles, eyelashes, etc. Refine smaller shapes. What are some of the smaller shapes within the large shape of the eye? What is the exact shape of the darker other eye? The upper lip?

Draw the shape of the eyebrow.

You certainly don't see a round iris. Draw the exact shape of the darkness you see.

Indicate the shapes of light that will be left as white paper. The teeth are not these. (Squint and you will see that they are actually darker than the light on his lip.)

4 Add Refinements and Values

Define the value relationships, as well as the smaller shapes with the larger ones: the small shapes of dark and light within the hair, the shapes that define the teeth (not an outline of them), the shape of stray hair that crosses the forehead. These aren't details, but refinements. If your search has been thorough, the result will be a realistic drawing.

HAVING A GOOD DAY
Graphite pencil on acid-free foamcore board
14" x 12" (36cm x 30cm)

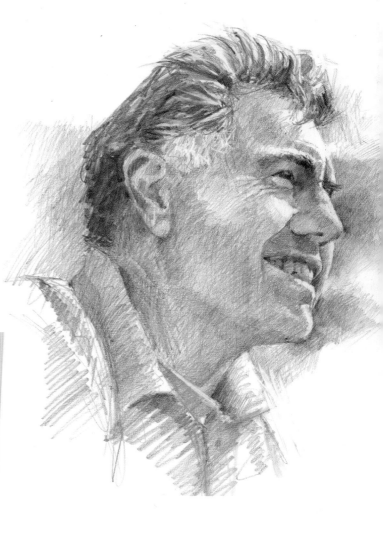

POINTS TO REMEMBER

···⟩ Make every drawing a search for relationships.

···⟩ It's OK to leave your search lines as they are—a record of you the artist.

···⟩ The only thing you can really draw is a shape, and the only way to get the shape right is to faithfully record the angle of its edges, its size relative to other shapes and the position of its key points in relation to other points.

···⟩ No amount of detail will solve your problems.

···⟩ Your analytical brain will try to substitute previously stored data in place of a search. Don't let it control the process.

CHAPTER 4

SEEING VaLUE

The term value refers to the quality of lights and darks in a work of art. People speak of colors in their daily conversations, but rarely speak of how dark or light something is in relation to its surroundings. It is because of light and shadow that we are able to see anything at all. The degree of value contrast between an object and its background is what makes it visible. A black cat in a coal bin is difficult to see. A black cat in a snow bank is hard to miss.

Value plays two roles in our visual world. First, it makes shapes visible. Second, the gradations of value in a form provide us with the information to understand its volume and planes. When you harness the power of value changes and value contrast, you will be amazed at the range of possibilities. In this chapter, we will explore the wonderful world of value shifts as they simulate the effects of light and make them work for us in drawing.

AUTUMN HARVEST
Charcoal and colored pencil on bristol paper
15" x 20" (38cm x 51cm)

Seeing value contrasts

Value alone does not make something visible, it is the contrast between the object's value and the surrounding value that does. In nature, camouflage is accomplished by reducing value contrasts. A white rabbit is more visible on a pile of coal than a snow bank.

Contrast is Clarity
These branches are a good example of how things are visible not because of what they are, but because of the degree of value contrast.

A dark shape against a light background makes this tree trunk highly visible. Your intellect will try to apply this information to all the limbs.

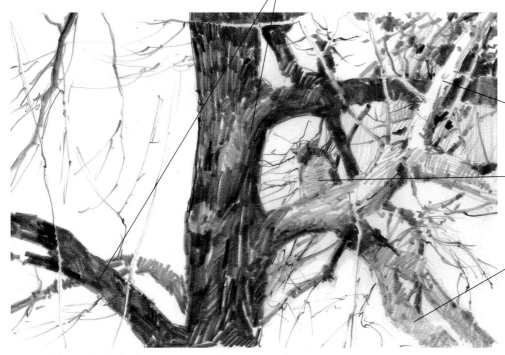

This limb is light, made visible by the contrasting dark limbs behind it. Even the sky is slightly darker.

The owl is one of the last things we discover because the value of his chest is the same as the tree limb below him. His color and the value on his chest are similar to those in the bark.

Even a minor value contrast will make a shape visible, though not eye-catching.

Values Are Relative
Value is a powerful compositional tool. If you make a shape the same value as its surroundings, it disappears. Value contrast will make the shape visible, while a strong value contrast makes it visually irresistible.

FROM THE ARTIST'S BRAIN
By controlling value contrast, you can direct the viewer's attention to the exact spot you want. You can also take the attention off other areas by decreasing the amount of contrast.

Light Against Dark

We have no trouble seeing the shape of this hill because it's surrounded by shapes with darker values. Even the lighter value of the foreground is darker than the parts of the hill bathed in light. It is particularly the dark shape of the background hill that makes the light hill so stunning.

This dark shape is responsible for the visual power of the light. Against the light sky, the equally light hill would lose its impact.

How visible is this boundary? There is a change in color, but little value change. Are there other places where edges blur?

The shadow shapes define the form.

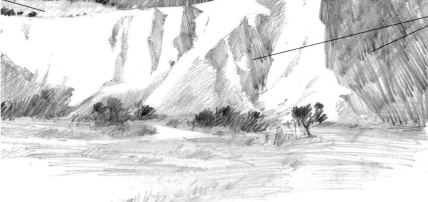

Dark Against Light

This scene features a dark shape against a lighter background. If the sky were dark, the contrast would be minimal and the effect would be less dramatic.

In a few places, the edge of the bridge is lighter than the background value.

The majority of this natural bridge is dark against a background of lighter values.

Using value to define form

Variations of value provide us with all kinds of information. For instance, the illusion of texture can be created by small changes in value on what would otherwise be a surface of uniform value. In the illustration below, the texture beneath the crack on the third rectangle looks like carefully rendered detail. However, all I did was roll a kneaded eraser across the area, and then I added shadows below or above the lightened areas to create the effect of light across a textured surface.

When rendering the effects of light and shadow that define a form, don't rely on some quick, glib bit of information supplied by your intellectual brain. Nothing can take the place of careful observation. Ask questions like: "What is the exact shape of the shadow area, and what does it tell me about the form?"

There are so many variables for the behavior of light that a complete list of rules would be impossible. Draw what you see, not what you think, expect or know.

A shape with no value changes and bounded by a dark line appears flat.

The sudden value change here reads as a sharp change of plane.

Reverse the values that simulated a bump to create the light falling on a depression in the surface.

A crack is not just a dark line. See how the gray of the surface plane is interrupted by the dark line and a lighter value line where the exposed edge catches the light.

Our daily experience usually involves a light source above us: lights, sky, etc. When we see a light spot with a shadow, we read it as a bump.

The core shadow down the center, the reflected light and the gradual shift in value from causes us to read this form as rounded.

Finding the Information in Value Shifts

Look at these three rectangles to illustrate how we "read" the value information. All three are the same shape, but because of the differing configurations of lights and darks within them, we perceive them differently.

Your most difficult technical problem is getting the various values correct.

"Right value" means the right relationships: How dark or light the value of one area or shape is compared to another. In order to see these relationships, you must compare them. In order to compare them, you need to simplify them. How do you simplify them? The answer is squinting.

Look at your subject, then slowly close your eyes until you can still see the large shapes but not the confusing little details. What's left are easily grasped shapes of value. You'll be able to see which is darkest, which is lightest and the gradations between.

If you look at the subject with your eyes wide open, your irises adjust to allow for maximum clarity in the area of your focus. On a dark area, an area in shadow for example, your irises open wider to accommodate for the lack of light and you will see more variety in value. The more of these details you see, the more you will miss of the larger shape and its value relationship to other shapes. If you shift your focus to a lighter area, your irises contract, allowing you to see the small variations within that area. You end up seeing far too many changes in value—more than you need to describe the forms, more than the drawing needs and more than you can cope with.

How to see values

Reference Photo
If you squint enough, the print on this page will become blocks of gray and the individual words will disappear. That's what you want. Squint at the large general shapes in this photo. The sky is a light gray shape. The background hill loses its details, and you see a large dark shape. The light hill divides itself into two shapes of value: shapes of light and shapes of gray. The foreground becomes a midtone. Squinting simplifies the information into a manageable form.

Squinting to Simplify
This is what you see when you squint. In this initial stage of the drawing, I have left out the dark accents which are everywhere in the photo. If I put down the large shapes of value first, I can then decide where I want those dark accents. Like the accent pillows in your living room, they are meant to accent, or to place emphasis. If you throw them all over your room or all over your drawing, the result is chaos.

Adding the Details
In this final version, the basic value shapes have hardly been altered. The dark accents have been added strategically to create a center of interest. Superfluous value changes in the major shapes have not been added. Squinting helps you avoid the trap of these little details.

Finding value relationships

Three things affect the value of any surface:

1. The local tone, or the actual value of the surface free from the effects of light and shadow.
2. The brightness of the light source. Even a dark local tone can have a highlight from a strong light source.
3. The direction of the light source. Surfaces at right angles to the light source receive the most. As a plane turns away, it receives less light and becomes darker.

Capturing These Relationships

There are numerous ways to render the changes of value you see. The method you choose is completely personal, a result of your likes and dislikes and your choice of medium.

Don't worry about developing a personal style. Learn to see value relationships, become familiar with the various media, and your personality will imprint itself on your drawings naturally. Later, I'll teach you how to render these relationships using the most common drawing tool, the graphite pencil, so you can focus your attention on seeing the relative value in the subject.

Everything Is Relative

Values are only evident in relation to other values—a light object will appear lighter next to something dark and vice versa.

The Different Areas of Value

A black and white sphere is a good illustration of the six different areas of values that form under a light source.

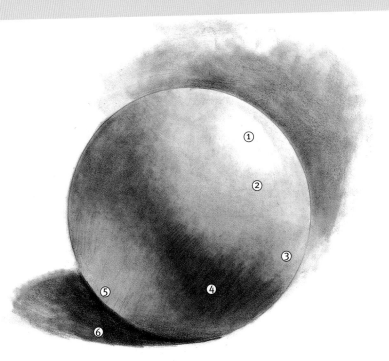

1 Highlight: The area receiving the most direct light.

2 Light: The surface area receiving indirect light.

3 Shadow: Where the form turns gradually away from the light source.

4 Core shadow: The most concentrated area of dark on the sphere. Since it is parallel to the light source (which is coming from above right), it receives the least amount of light.

5 Reflected light: Light bounced back from nearby surfaces. Reflected light is still part of the shadowed area and as such is never lighter than the shadow area on the lighted side of the sphere.

6 Cast shadow: The shadow cast by the object is almost always darker than the core shadow. The length of the cast shadow depends on the position of the light source. It's darkest and its edges are sharpest nearest the object.

It is impossible to create with any medium the full range of value shifts that you can see in nature. Simplifying the range is a necessity. Most artists use the standard value scale, which divides the ranges of value into nine increments: a middle gray, four gradations of darks and four of lights. This may not seem like a lot, but it's actually about as many as most people can easily distinguish.

Creating your own value scale is a useful exercise for learning to adjust a value to the values around it. Divide a 9-inch (23cm) rectangle into 1-inch (3cm) segments. Using a 2H pencil and very little pressure, shade the first segment a very light gray. Switch to a 6B pencil and make the last one as black as you can get

it. Now shade each of the remaining segments in even jumps between these two extremes. You may want to use a blending stump to even out the value in each segment.

Two problems will arise: First, the transition from one segment to the next may vary—you might have a minor jump in one place and a huge jump in another. If you adjust one, you have to adjust all the rest. Note: it is easier to make a value darker than lighter.

Second, the value in one segment may become lighter as it approaches the border of the next. This will cause you to shade the next segment incorrectly because you're basing it on the border value and not the interior. As always, it's helpful to step back and squint.

Making a value scale

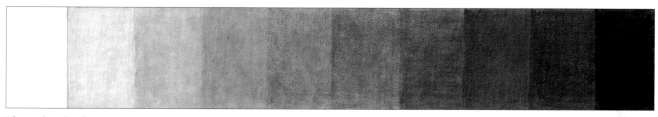

The Value Scale

Practice With Your Scale
Gather a few simple items that are light in value. Hold up your value scale and find the square that most closely matches the value of an area. Comparison is one of the most important abilities needed.

Practice With Your Pencil
Here is a great subject for drawing value relationships and the effect of light on a curved surface. Squint and use your scale to capture the values correctly.

Rendering Shapes of Value

All forms, from people to trees, are made of shapes of varying value. Some of these shapes are very distinct and some have blurred edges. Accurate drawing requires seeing and recording the configuration of each value shape, their relative values, and the edges where these shapes meet. This gull is made up of light, gray and dark shapes. Forget about the bird and focus on the value.

Reference Photo
Your intellect sees birds in terms of legs, feathers, eyes and beaks, not shapes of value. Take your focus off these nameable items and put it on shapes.

1 Begin with a Search for Angles
Begin with the angle of the shapes, the relative size of each shape and the relative position of key points. After that, you're ready to conduct a search for relative values.

2 Establish a Range of Values
There is no right place to start adding value to a drawing, but if you're comparing values (and you should), establish a standard to compare them against. I look for one of the extremes of white or black and begin there. Compare the lighter range of values to the white of your paper. This subject has a black shape. Perfect!

When you squint, you see that there are two tones in the dark shape: black and a dark gray as the rounded plane of its back turns toward the sky. Put this black in with a 6B pencil. Now you have a standard of comparison for the gray tones.

This is the darkest value on the bird. Notice how it gets lighter as it moves up the back.

These two areas are the same value.

Establish the Middle Grays

This is where squinting is crucial. Your intellect tells you that the bird is black and white. Beginning students typically accept that information and hesitate to violate the white very much. Consequently, the shadow area is rendered far too light. Squint and compare the value on the back of its neck with the dark gray of the light-struck back. A highlight on the black shape is the same value as the shadow on the white shape!

Every dip and turn in the shape of the gray is important: Each turn, each change in the edge tells you where the form turns in space, where it dips or bulges.

The shadow area on these white feathers is the same as the shadow on its neck.

This shadow is the only information about the undulations in the chest and neck. Change it and you change the bird.

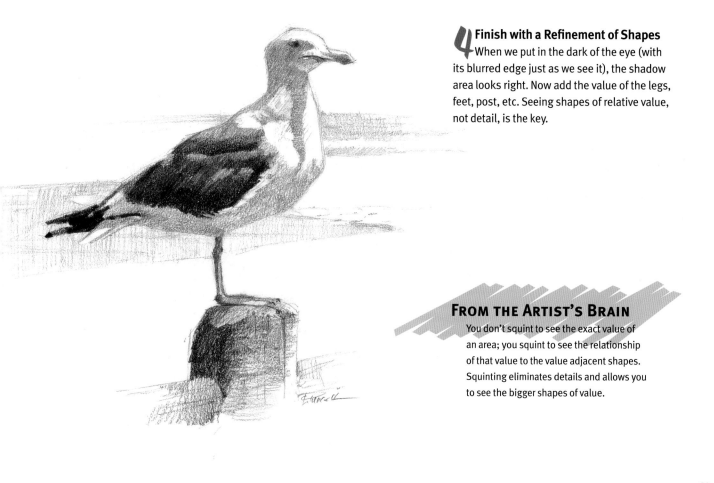

Finish with a Refinement of Shapes

When we put in the dark of the eye (with its blurred edge just as we see it), the shadow area looks right. Now add the value of the legs, feet, post, etc. Seeing shapes of relative value, not detail, is the key.

FROM THE ARTIST'S BRAIN

You don't squint to see the exact value of an area; you squint to see the relationship of that value to the value adjacent shapes. Squinting eliminates details and allows you to see the bigger shapes of value.

Methods of rendering value

The method you choose to create values using a graphite pencil is your choice. Some prefer crosshatching, some prefer to blend, and some (myself included) prefer to create the value with strokes that also define the shape. This latter technique is called broad-stroke.

For the bulk of my drawing, I like the directness of adjusting the pressure of the pencil to achieve the right value. It's similar to allowing paint strokes to become part of the finished work instead or blending them perfectly.

Getting the value relationships right is far more important than the method you choose. But, so you can see how these methods appear in a finished drawing, I've done the same drawing three times, each employing a different method. In all three, the darkest and lightest areas are the same as well as the relationship of grays. Only the technique differs.

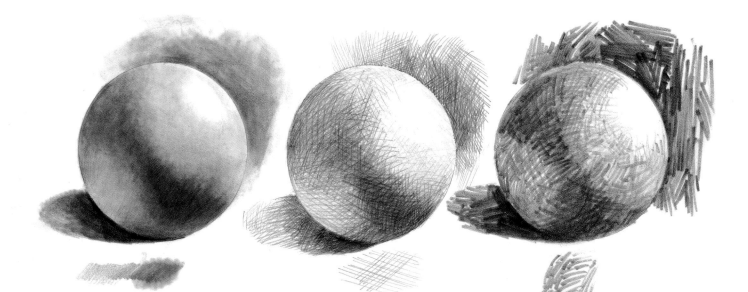

Blending
Graphite can be blended and rubbed to achieve a nearly photographic effect. In this drawing, I used a 2B pencil for the darker areas and an HB pencil to lay down the lighter values. I then went over the strokes with a blending stump.

Crosshatching
Cross-hatching is a series of straight parallel lines, overlaid by more lines running in opposing directions. These are built up gradually to achieve gradations of tone. Cross-hatching should be used for gradations in tone, not to establish the shape of the rounded form.

Broad-stroke
This stroke differs from cross-hatching in two ways. Instead of using a sharpened point, the end of the graphite is sanded down at an angle to create a chisel point. Also, the strokes follow the plane and vary in length. This is my personal favorite for use in my sketchbook because it's fast and re-enforces the planes in the subject.

Blended Graphite Method
CLOVELLY DRY DOCK I
HB & 2B Graphite pencil, 9" x 12" (23cm x 30cm)

Crosshatching Technique
CLOVELLY DRY DOCK II
0.5 mm graphite pencil, 9" x 12" (23cm x 30cm)

Broad-stroke Method
CLOVELLY DRY DOCK III
6B graphite pencil, 9" x 12" (23cm x 30cm)

Variations in Value and Defined Edges

After our eyes process the scene in front of us, the image is sent to the intellect for clarification and identification. When it's finished, we believe we saw it in perfect clarity. But we didn't. For our art to look like what we see, we must focus on the visual information.

And what did we see? We saw shapes: some with sharp, focused edges; some with vague, barely defined edges; and edges that were completely lost. We saw the value change from one side of a shape to another.

Reference Photo

This old granary is a good example of the way we typically see. Some of the shapes are fairly well defined, like the roof and the side of the building, giving the impression that it's all in sharp focus. In fact, where the front of the building meets the ground is not in focus—there's a general fuzziness about the shapes in that area.

If you try to define every board, blade of grass, etc., you're headed for disaster. For example, you really can't distinguish each board. Trying to do so would be like counting fleas on a rhino.

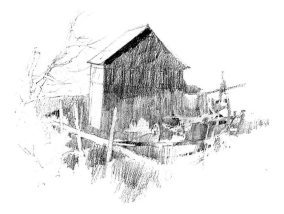

1 Start with a Shape

Begin the drawing with a shape you can readily manage, like the roof shape. It's skinny, and two of the edges are parallel. Concentrate on the two angles at each end. Drop lines down for the left side, and measure their length against the length of the roof. Establish the distance to the other side and put in the other pitch of the roof. Now you can relate all other shapes to that.

2 Squint to see Shapes of Value

Squint at the photo. Where are the shapes of light? What happens to the value of the shed? Does it remain the same from top to bottom, or does it change? Find where the shape's edge is hard to read because it's so close to the value of the adjacent shape. Duplicate that in your drawing. Resist the urge to clarify it.

Draw vertical boards by drawing the spaces between them.

These negative spaces suggest boards.

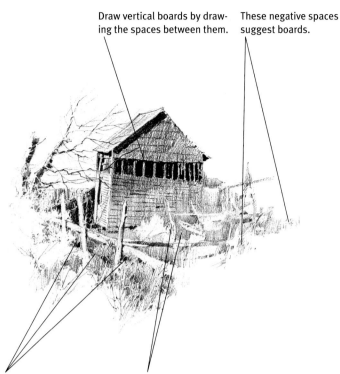

These shapes of dark space give all the clues we need to see the posts.

Instead of drawing the wagon wheel, draw the dark shapes between and adjacent to it, and the wheel will appear.

3 Draw the Spaces

This step appears to be one of identification, but look closely. If you draw the darker shapes of space, the lighter shapes will become recognizable. Many artists refer to this as "negative painting."

For example, it is the shape of dark space to the right of the wagon wheel and the dark shapes between the spokes that define the wheel. When you put in the dark window shapes, the boards in between are drawn by default. Your intellect does not see these shapes, only objects.

4 Make the Final Decisions

If you draw shapes instead of things, you will also know when to stop. You can look objectively at the value shape made by the entire drawing and adjust accordingly.

Look at the drawing and decide how far out to extend the shadow shapes in the weeds at the lower left. Add the shapes of value in the tree. Lean the tree into the subject a little more to help direct the eye around the composition. The dark accents at the left of the building and at its lower right corner help to build a center of interest. Notice there are no dark accents in the peripheral areas.

THE GRANARY
Graphite on bristol vellum
7" x 10" (18cm x 25cm)

73

Seeing Shadow Shapes in a Portrait

The more complex the subject, the more fun to draw. Certainly one of the most challenging and rewarding is the portrait. In order to achieve a realistic likeness to the person being drawn, every relationship—size, angle and value— must be correct. However, it's immensely satisfying to do a portrait that captures the character of the sitter.

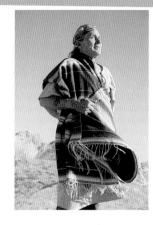

Reference Photo
I met Billy Ayers years ago in Nevada. He's a Choctaw Indian and very personable. I took this photo of Billy in the Valley of Fire north of Las Vegas.

Out of context, the shapes defining the eye are very abstract.

Squint to see how dark one area is in relation to another. The changes are often slight.

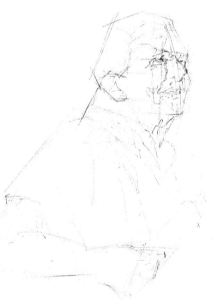

Many edges dissolve into the adjacent area. Don't give sharp focus to an edge unless you see a well-defined edge.

1 Block in the Basic Shapes
Where do you start? Pick a shape that's easy to see. What makes one shape easier to see than another? Simplicity—a triangle, for example, with well-defined edges. Many shapes in portraits are indistinct or have a number of indistinct edges. Draw those edges lightly so you can create a soft edge later, without having a dark line to contend with. The dark value shapes of the eyes were the most well defined, so I started there.

2 Add the Values
Values are just shapes! The shapes of value define the forms. Things in our visual experience are not defined by a black outline as they are in a coloring book; they are defined by value contrasts. If we draw these shapes exactly as they are and give them the proper value, they will define Billy's features exactly.

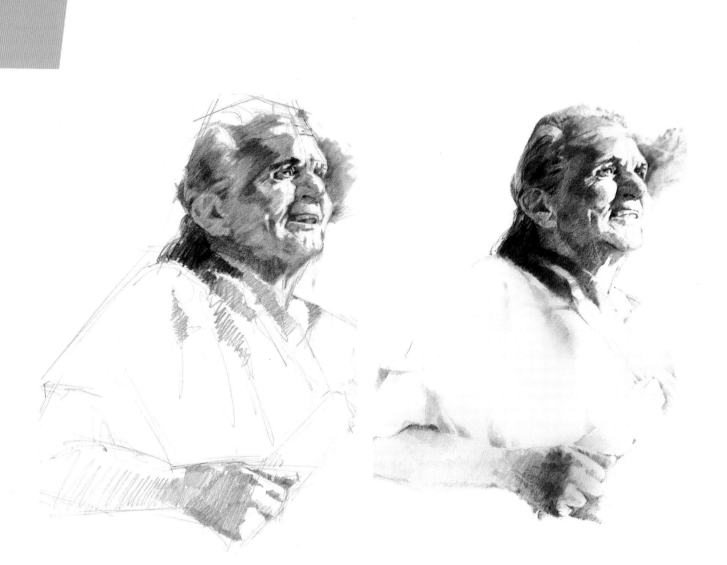

3 Establish the Value Range

Remember, every time you look at your subject, squint to see the value relationship. Establish the general value over an entire area, then break up the area into smaller shapes of darker value—like those that make up the ear.

Put in a gray shape, not teeth. Many beginning artists allow the influence of their intellect in the whites of the eyes and teeth. Very seldom do we really see these as "white" because they are usually in shadow.

4 Choose the Essentials

Choose only the elements you need to convey the essential information. If you draw shapes instead of things, the decisions are easier to make. (I chose to blend the strokes, and I used a blending stump to draw the value shapes in the robe and arm.)

BILLY AYERS, GENTLE WARRIOR
Graphite on bristol vellum
18" x 15" (46cm x 38cm)

Values in Landscapes

Like the figure, a landscape is made of shapes of value. Squint and you will see that a tree's foliage can be broken down into irregular shapes of lighter and darker values. The telling details of leaves and branches occur at the edges of these shapes. And, just like the figure, the complexity of a landscape can be conquered by drawing one shape at a time, each one in relation to the last.

Reference Photo
My wife and I were driving in Devon, England, and passed this country home.

The strokes follow the curved plane of the ground.

Vary the length and direction of each stroke but maintain a single value for the shape. The light left between strokes helps create an uneven surface.

Figures add interest.

Even though the wall is not white, leave it white at this end to increase the contrast in the center of interest. The other end is light gray.

1 Analyze the Shapes
Begin with the most obvious shape—the rectangular roof. It's the easiest shape to get right. The distance between the top and bottom is exactly half of the length of the bottom edge. Add the angles at the ends and you're done.

Visualize the scene as a drawing. Try to anticipate problem areas and solve them in your mind before you begin. Place the roof shape where you want it on your paper. Now the other shapes can be drawn in relation to the roof shape, one at a time. Don't draw the trees: Draw shapes of foliage.

2 Add Value to the Shapes
Begin in the center of interest and establish the value range. The rock steps break up the area into smaller shapes. Add figures to emphasize the center of interest.

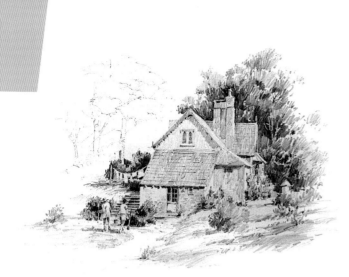

3 Continue Shape by Shape

The top window really stands out because part of the windowsill is white, the interior spaces are black, and these two value shapes are surrounded by a light gray. We can change what we see for the sake of the composition: Lessen the contrast a little.

Study the foliage for its character, and then create similar shapes. Stay away from black—save it for the center of interest. Edges are the only thing needed to identify the leaves.

4 Put it All Together

This is what I envisioned when I looked at the subject. Of course, I couldn't visualize all the details and every stroke, but I knew the overall composition and the center of interest. Adding the figures gives a little life to and strengthens the center of interest.

Put in the value shapes for the trees on the left. As you add the shapes, keep backing off to see how they affect the overall shape of the drawing. You want a varied edge, loose and undefined. A hard end is like stopping music abruptly. Let it taper off and reserve the darkest accents for the center of interest.

DEVON COUNTRY COTTAGE
HB & 6B graphite pencil on bristol plate
8½" x 12" (22cm x 30cm)

The darker value here defines the tree trunk. Notice that the upper part has a shadow cast over it from the foliage above.

Put foliage in front of the trunks. Only once have I ever see a tree that had all the branches in front and all the foliage behind. In a drawing, it looks even more unbelievable.

Don't make shapes like this quite as dark as they appear in the reference.

Indicate the bricks a bit darker than the surface, but resist the temptation to put draw them all. Use one stroke per brick. Keep it simple.

POINTS TO REMEMBER

⤍ The degree of value contrast between an object and its background is what makes it visible.

⤍ A strong value contrast makes a shape visually irresistible.

⤍ Variations in value define texture and form.

⤍ Squinting will simplify the details of a subject allowing you to better observe the relative values.

A short course in broad-stroke

I had to discover the traditions of the masters on my own. In the library, I found drawing books by Ernest Watson and Ted Kautzky. I loved their drawings. They presented the visual world in a clean, fresh manner that appealed to me. Their pencil technique was broad-stroke.

Broad-stroke drawing is very much like oil painting. It is a direct, finish-as-you-go method. I adopted the broad-stroke technique for my own field studies. It gave me a way to quickly set down the broader shapes of value and a means to skip past my intellectual brain's craving for details.

Every year I fill at least one sketchbook with quick drawings in this manner. These drawings become the catalyst for many paint-ings. I use my camera for gathering color and detail information, but the drawings preserve the feeling of the moment, the inspiration that stopped me and, yes, forced me to draw. My camera cannot capture that emotion (and neither can yours). I sometimes look at a photo and cannot for the life of me figure out why I took it! I never have that problem with a drawing because the drawing distills the essence of the forms and the exciting shapes from the subject. It eliminates the unnecessary trivia that the camera must record.

The following are some excellent uses for broad-stroke. It's a particu-larly wonderful technique for cap-turing rough and irregular textures.

Rock Walls

In drawing rock walls, you must think like the mason—alternate the size of the stones to create an interesting pattern. He uses large stones at corners to strengthen the wall and small stones to fill in the spaces. A mason achieves a better bond by not breaking the joints.

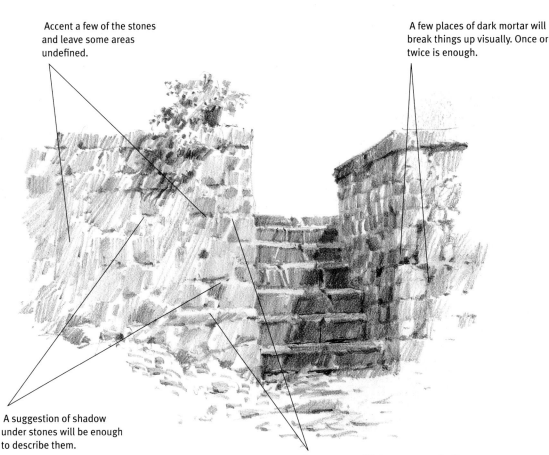

Accent a few of the stones and leave some areas undefined.

A few places of dark mortar will break things up visually. Once or twice is enough.

A suggestion of shadow under stones will be enough to describe them.

Leave areas of light to serve as both mortar joints and reflected light. Randomness is key.

Brick Walls

Nothing compares to the knowledge you gain by going out and looking at a wall. And I mean really looking; not that quick glance for identification your intellect is famous for. Look at it as a drawing. Squint and see the patterns of value. Take note of how the value differs between individual bricks or stones. Notice how texture affects value. Notice how light plays across the top surface of the rocks.

The courses of bricks must conform to the laws of linear perspective, converging toward a vanishing point.

Don't spell out every brick. I probably went too far, but if part of the wall is brick, assume the rest is too.

Think reflected light and the places that receive less.

Siding and Shingles

First, squint to see the relative values of the walls and roof. Lay in each value using strokes of varying length.

The irregular shadows are caused by separation of the boards. Vary the angle of the pencil to create lines of varied weight.

Don't draw shingles; draw the shadows at the butt of the shingles. These are a series of parallel lines varying in thickness and value. Restraint is a virtue.

What unique marks will help tell the story? The triangular shadows at the end of the boards are an example. These details explain form.

These trees are made with strokes that follow the rounded contour of the foliage. Shadow shapes and a few gray branches give all the necessary information.

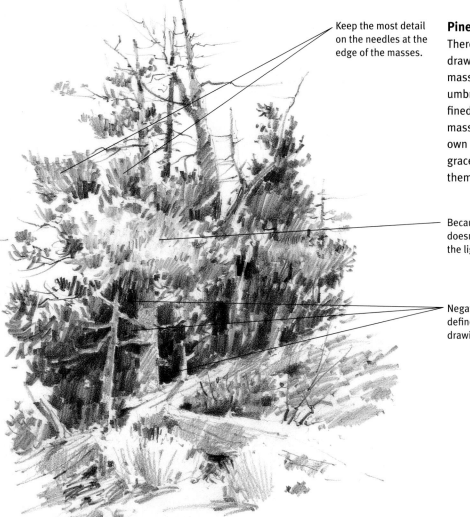

Keep the most detail on the needles at the edge of the masses.

Pine Trees

There are two things I consider when drawing trees. One is the contour of the masses of foliage: Is it a canopy, like an umbrella? Is it a ragged mass with undefined contours? Or is it like a pine tree—a mass with spiky edges? Every tree has its own rhythm of branching, ranging from graceful elms to erratic aspens. Study them.

Because the foliage is green doesn't mean it's dark. Vary the light.

Negative spaces can often define forms better than a drawing can.

Rocks

How often have you seen rocks in paintings that look like marshmallows? What are the identifying characteristics of rocks? They're hard. They break into sharp facets with angular edges. Marshmallows aren't like that at all. So when you draw rocks, go for the most characteristic ones you can find, not those worn down like marbles.

Details on the lighted planes will be light, not black.

Cracks are defined by both the dark crack and the light-struck edge.

The actual shadow shape defines the contours of the rocks.

Keep the direction of light in mind throughout. Any plane facing it will be lightest.

Make your strokes describe the plane direction.

Practicing broad-stroke

Make broad-strokes deliberately and at a steady speed, not too fast or they will look sloppy, not too slow or you'll lose control. Do not make strokes with finger movement. Hold the pencil firmly in your fingers and move your arm instead.

Sharpen a soft pencil, 2B or 3B. Hold it at an angle to the surface of a rough paper or a sanding block and gently rub it back and forth in one direction until you have created a chisel point. Hold the chisel edge flat against the paper and make a stroke as in A. The stroke will be wide and of one value. After practicing flat, broad-strokes of similar value, try a couple of variations. If you tilt the pencil very slightly toward its point, it will produce a stroke that is darker and accented along that edge and fading out along the other edge, as in B. Tilt the pencil slightly away from its point to produce the reverse, as in C. Roll the pencil very slightly either toward you or away from you, and hold it that way during the stroke to produce a darker line with the same pressure—as in D. Tilt the pencil up so that the tip rests on the paper to produce a thin line similar to one made with a pencil sharpened to a conical point, as in E.

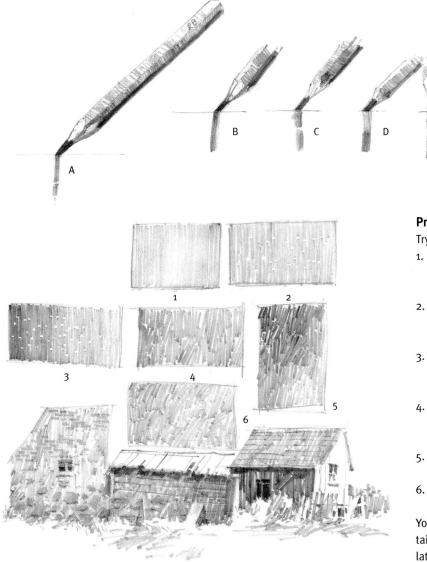

Broad-Stroke Paper

Paper with a smooth surface, like bristol (plate finish), is best for broad-stroke. For my sketchbooks, I find ones with the smoothest surface possible. Try the blank book section of bookstores. Many sketchbooks in art stores have paper with varying degrees of tooth, which doesn't work as well.

Practice

Try the following exercises as shown in the illustration.

1. Fill a rectangle with strokes, each one touching but not overlapping the previous one, to produce a rectangle of flat, even tone.
2. Fill a rectangle with similar vertical strokes, but this time vary the length of each stroke and leave a small bit of white paper between the ends of the strokes.
3. Do a rectangle as in 2, except this time gradually reduce the pressure on the pencil to create a gradation in tone from left to right.
4. Fill a rectangle with strokes similar to 2, but include a few places where you introduce diagonal lines of varying lengths.
5. Try the same approach as in 4, but grade the values from dark to light.
6. Try the same thing as in 4 but with short curving strokes.

You can see how a few broad-stroke suggestions of detail can create the impression of brickwork, rock walls, lateral siding, vertical boards or shingles.

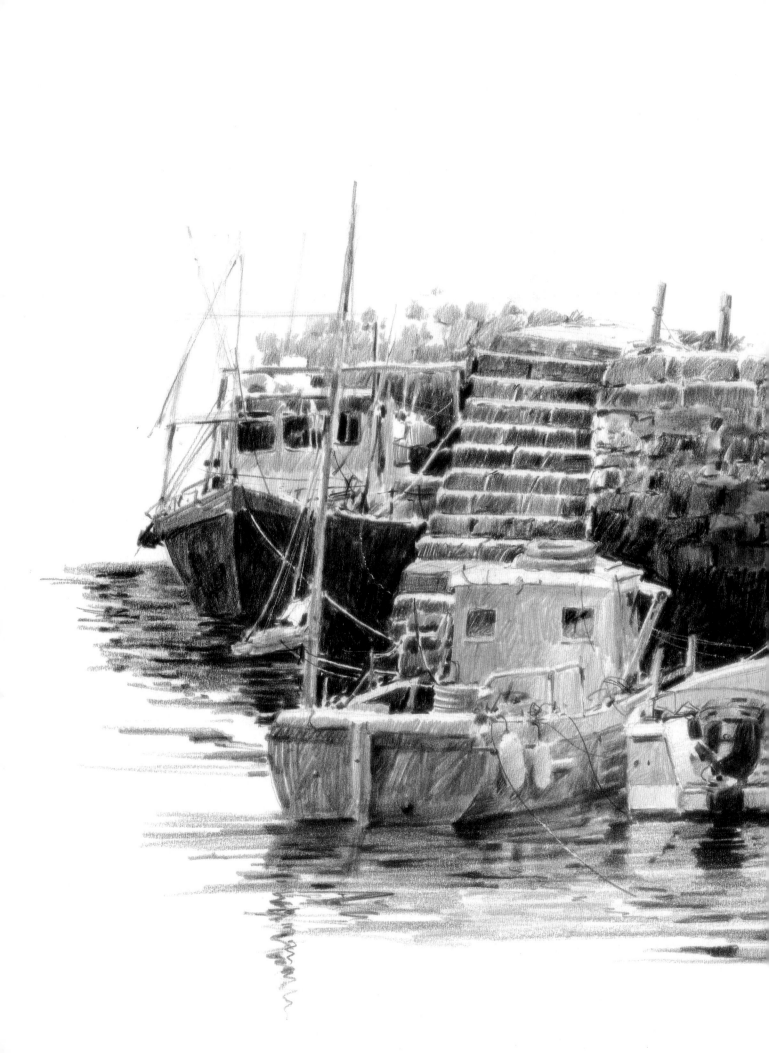

CHAPTER 5

figure and ground RELATIONSHIPS

The visual world is a complex tapestry of value relationships. Fortunately, it's not beyond the scope of our powers of observation—and good drawings are records of intense observation. Discovering these complexities through drawing is a wonderful experience. When you really look at the world around you in the way that drawing requires, you discover that simple, ordinary objects are not only extraordinary (as Frederick Frank says), but that they exist in a wonderfully complex relationship with the space around them. Don't fear this complexity; embrace it. The drawings that result will be your reward.

The relationships between objects and the space surrounding them are referred to as figure and ground (figure/ground) relationships. Some describe this relationship as positive/negative or foreground/background. In this chapter, we will explore the value relationship between objects and the space around them. When you understand what you see, you can incorporate that understanding into your drawings. It enhances their aesthetic sense and imbues them with convincing reality. You can only get so skillful at putting marks on paper. Marking based on observation is the genie that puts real magic into your drawings.

TIED UP IN BRIXHAM
Colored pencil and Conté crayon on plate bristol
9" x 11" (23cm x 28cm)

Defining "figure" and "ground"

Sometimes the relationship between figure and ground is fairly simple; however, most of our visual experience is with complex figure/ground relationships that require sorting out. These two examples demonstrate what I mean.

Study the group of figures on the bench, and take note of where a figure is bordered by actual space and where it is bordered by another figure. Notice also the relationship of the values at these places. You will find that it constantly shifts from a figure that is darker than the value next to it, to one lighter than the adjacent value. And sometimes the values are the same and you can't tell where one ends and the other begins. These lost edges are part of our visual experience; don't feel a need to correct them.

An Obvious Relationship
The relationship between figure and ground is straightforward. The Scotsmen are the figures, and all the space around them is ground. Some parts of the figures are lighter than the ground, some darker, but the figures are easy to define.

Blurred Lines between Figure and Ground
This is the visual complexity we experience every day. The background of one figure is sometimes space, or sometimes another figure. For instance, the space around the man's right arm is not space but is actually the woman next to him. In this case, his arm is figure and her body is ground. The white value behind the woman's hat is another's hair, etc. Very often a positive item can serve as ground for another figure or object. Just think of the value bordering the shape which you are currently drawing as ground, whatever it happens to be.

I don't want to destroy any beloved delusions, but the coloring books we grew up with lied! There are no clear, easy-to-stay-within black lines around anything in the visual world. Everything is defined by value changes, not lines.

Like human relationships, the value relationship between a figure and its surrounding space (ground) can be boring or exciting, static or active. What makes the difference? Interaction. If two people do not interact, there is no relationship. If a figure and its adjacent ground do not interact through value, there is no relationship. These photographs illustrate three levels of figure/ground relationships: Static, Reversing and Alternating.

Figure/ground value relationships

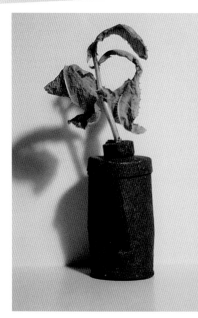

Static: Dark Figure, Light Ground
This is a static relationship in which all the dark values are in the figure and all the light is in the ground. It may be very clear, but there is no give or take.

Static: Light Figure, Dark Ground
The opposite also makes for a static relationship. The light figure is separated from the dark background. It would make a horrible marriage.

Value Reversal
Reversing the relationship ties the two together. Begin the figure as dark against light, then switch. This creates an active partnership—common in the visual world.

Value Alternation
The most common visual relationship we encounter is an alternating relationship. It represents the constant state of flux between figure and ground. This invites the most viewer participation.

Reversing the values

Your intellectual brain, the one that names the images and simplifies information, also separates an object from its surroundings, and if forced, assigns a value to it. "Tree trunk—dark!" "Leaves—light!" It does not, however, acknowledge gradations of value or relative value. These are seen only by your artist's brain.

See with Artist's Eyes
Are the limbs on this Juniper tree dark or light? See how they change relative to what is behind them? Look around and you will see this everywhere. I first noticed it in a drawing, having never even noticed it in the world around me.

In the upper half, the figure is all lighter than the ground.

This area is the bridge that creates a seamless transition.

This time the figure at the top is darker than the ground.

The lower part of the figure is darker than the ground.

The bridge occurs on both the figure and the ground.

Create transition in both the figure and the ground.

The lower part of the figure is now lighter than the ground.

Create transition where the change occurs.

Areas of Transition
This drawing presents the subject from the last page in a reversal of values. It begins in the upper half with a light figure against a darker ground, then switches just below the can's lid to a dark figure against lighter ground. Notice the transitions where the changes occurs. Like music, a new key is introduced through bridging measures that make for a smooth transition. Similarly in drawing, a sudden change would be awkward.

Either Way Works
Here, the upper half is darker than the ground and the lower half is lighter. Decide beforehand which arrangement of values you prefer. You will find that thinking of the background as areas of value that compliment the figure will help free you from the tyranny of the photograph. Instead, you are the master of what adjoins your subject.

Value reversal is the first level of complexity in figure/ground relationships. As much as your intellect would like you to believe, the reality of your visual experience is not clearly defined. In order to identify the objects around you, your intellect lifts them out of their context and resolves visual problems (where the figure and ground value are the same), leaving you with the impression of a clearly defined surrounding.

If you want your drawings to reflect visual reality, you have to sidestep this intellectual trap and look for the value relationships that really define the objects you see. The complexity of these relationships is the stuff of which beautiful drawings are made.

Alternating values

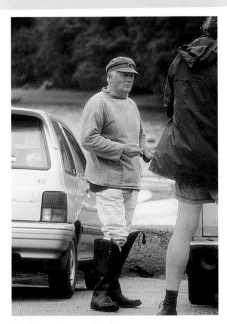

Embrace Complexity...
If you look past the obvious (a man in a gray cap, gray pullover, white pants, black boots) to the value relationships along the edges of his shapes, you will see something much more complex.

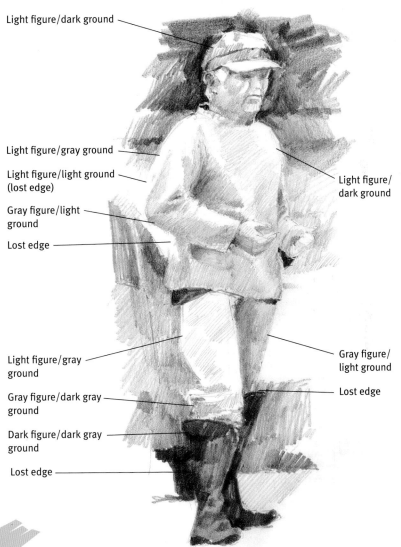

Light figure/dark ground

Light figure/gray ground

Light figure/light ground (lost edge)

Gray figure/light ground

Lost edge

Light figure/gray ground

Gray figure/dark gray ground

Dark figure/dark gray ground

Lost edge

Light figure/ dark ground

Gray figure/ light ground

Lost edge

FROM THE ARTIST'S BRAIN
Value reversal is not a trick or an artistic gimmick; it is a fact of the visual world. Look and you will find it.

...And Capture it
Squint your eyes and take a trip around the edges of the man where he meets the ground. Limiting the value scale to light, gray, dark gray, and dark, how many changes can you find along the way? There are over twenty. I have indicated twelve. This is the real information you need to be aware of when you draw.

Don't rush; get involved

If you say, "Oh, that's too complex for me!" Don't listen to yourself. That is your intellect speaking. Your visual brain enjoys this as much as your intellect enjoys crossword puzzles or complex novels. Draw what you see.

As you get involved with the value relationships along the edges, you will slip into a mental mode much like meditation.

Using Value Contrast

Even if we're aware of concepts like value reversal, when we look at this drawing, we see the flowers first. I even *did* the drawing, and still I see the flowers first and the visual concept second. That's because the stark white-against-dark background resonated inside me when I first saw the flowers . The drawing emphasizes that contrast. I am always drawn to the same thing here—the strong value contrast.

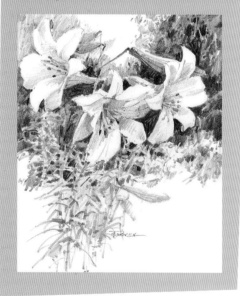

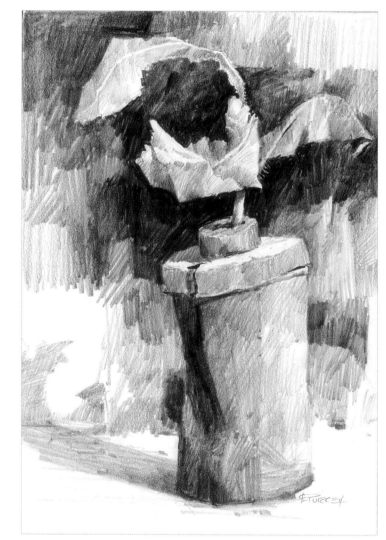

Try Different Relationships

This is an example of the alternating relationship applied to the same subject used on page 86. If you think, "What kinds of value relationships do I want along the edge?" instead of, "This is the can and this is the leaf," you will be free to invent. You will also be able to draw better because disciplined observation gives you the freedom to draw anything.

Enjoy the shifts in figure/ground value relationships as you would enjoy the intricate twists in the plot of a well-crafted novel or the changes in a Beethoven sonata. One of the most overlooked and yet most important aspects of any subject you choose to draw is the quality of the edges where the shape meets space. The appearance of these edges is affected by many factors:

1. The nature of the form—what it's made from. (Clouds will have softer edges, rocks harder, etc.)
2. The relative value of an object's edge and the adjacent ground value. If they are in sharp contrast, you will have a distinct edge.

If they are the same value, the edge will be lost.

3. The lighting—a soft, diffused light will not produce as sharp an edge as direct bright light.

To draw an edge correctly, you must be able to compare it to other edges. The only way to compare is to squint.

Once you are aware of the different kinds of value changes and kinds of edges you see along forms, you are free to create your own. You can create a value relationship between a figure and its ground as subtle or dynamic as you want.

Enjoy the complexity

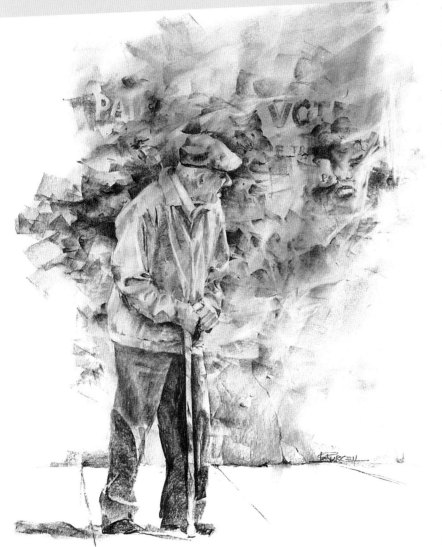

Create Your Own Relationships
I photographed this man against a busy street scene. I decided that I liked the complexity along the edges but didn't like all the buildings and people. I began with pieces of value placed next to the lighter edges. They suggested a textured wall. Notice how many times the value relationship between figure and ground changes.

POSTER WALL BUS STOP
Sepia Nupastel on sanded bristol board
20" x 15" (51cm x 38cm)

Alternation Drawing

I refer to drawings that exhibit constantly shifting relationship of values as alternation drawings: the value relationship between the figures and the ground constantly changes. It's necessary to simplify the variations in value to a manageable range. The value scale includes nine increments between black and white. Simplify these into three broad ranges: the lights, the middle grays and the darks.

Reference Photo
You can't pose this kind of subject, and you take what you can get for the value relationships. I did manage to do a quick sketch after I took the photo, but the photo was necessary for a finished drawing. The figure/ground relationships aren't ideal, so new ones had to be invented.

1 Start with the Subject
Fill in the existing relative values of the subject. Don't be afraid to squint!

2 Add Adjacent Values
Add values in a pattern designed to bring out the subject's head as a light form against dark. Envision a pattern that counters the major thrust of the subject. The little bird is dominantly horizontal, so I made the pattern counter in an oblique thrust.

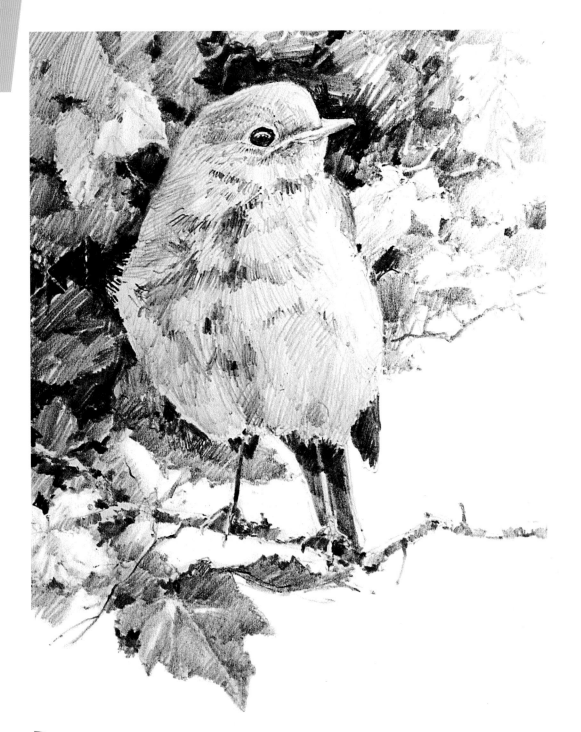

3 Finish with Accents
In the final stage, I added dark accents in the pattern to suggest leaves and foliage, then gave him a branch to stand on instead of the wrought-iron chair, which overpowers him in the photo.

LITTLE VISITOR
6B graphite pencil on bristol paper
9" x 7" (23cm x 18cm)

Manipulate value relationships

Pick an object in the room, and note how many times the value relationship changes around its perimeter. There may be as many as fifteen or twenty shifts in value relationships around a single object. Include this constant shifting in your drawings and you will mimic the dynamic complexity we see. If your subject is still lacking in complexity, go ahead and alter the actual value relationships to make them more interesting. Remember, don't be a slave to the photograph.

Reference Photo
I spied this man in a quaint English fishing village. He was nice enough to allow me to photograph him. In cases like this, you have to settle for a photograph because you can't get them to come to the studio and pose.

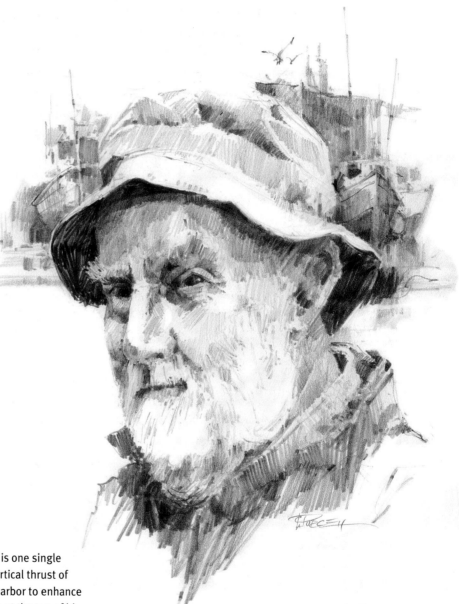

The Alteration Drawing
The figure in the photo is great, but the ground is one single gray: It needs a value pattern countering the vertical thrust of the head. I decided to suggest boats from the harbor to enhance his "salty" appearance. I decided on a lost edge at the top of his hat. Emphasis was on changing the figure/ground relationship as often as possible.

SEA SALT
6B graphite pencil on bristol,
9" x 8" (23cm x 20cm)

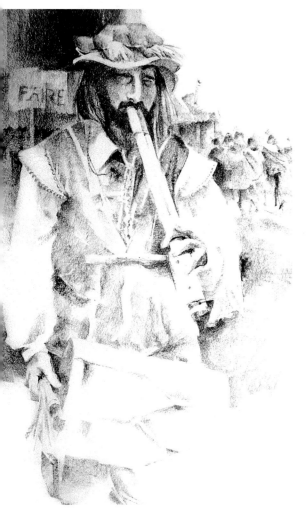

Watch for Lost Edges

This drawing is basically a value reversal drawing of the two shoppers checking their purchases but has a number of lost edges and subtle changes. Even the pigeon in the foreground is a value reversal figure.

WHAT DID WE BUY?
Charcoal on bristol paper
11" x 14" (28cm x 36cm)

Emphasize Your Edges

How many times does the value relationship change along the edge of this figure?

STREET MUSICIAN
Conté rayon on bristol paper
14" x 11" (36cm x 28cm)

POINTS TO REMEMBER

- ⤍ Drawing makes you aware of the world's wonderful complexities.

- ⤍ There aren't black lines separating objects from their environment.

- ⤍ Value changes not only describe the edges of forms, but can also tie those edges to the adjacent space.

- ⤍ Don't allow your intellect to simplify value relationships. Look for infinite variations and you will find them.

- ⤍ You're the boss. Don't become a slave to the subject or to a photo.

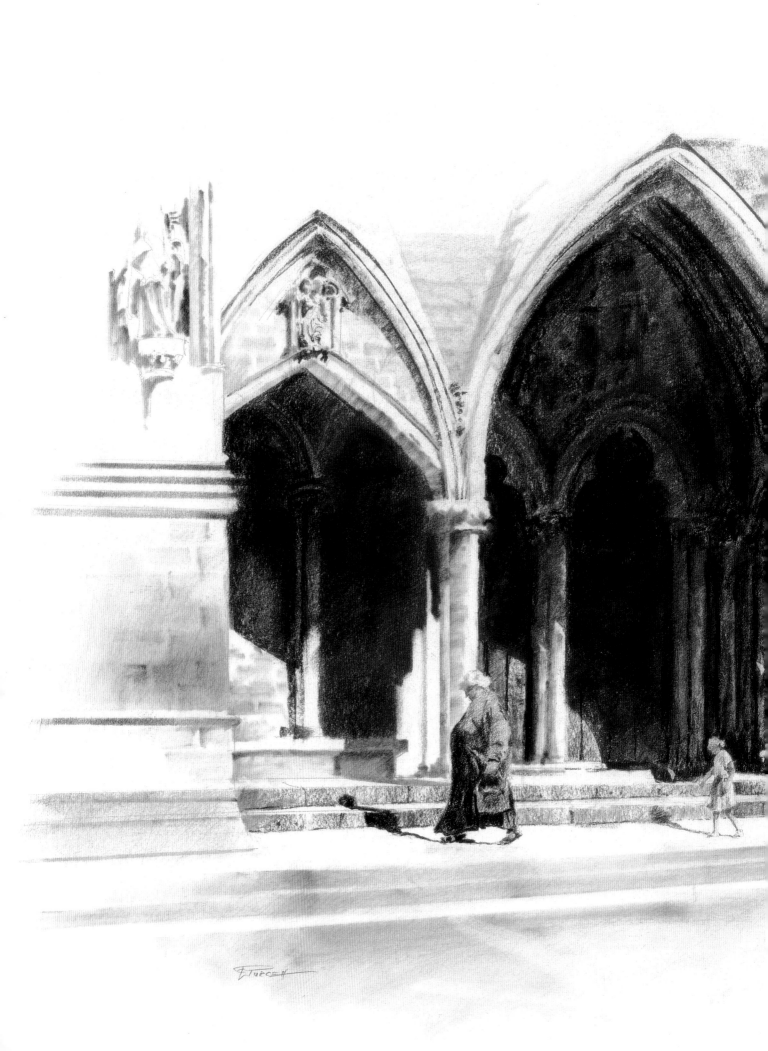

CHAPTER 6

organizing patterns of
value

We have explored some of the most important concepts in drawing: seeing relationships of angle, size and position, seeing the relative value of shapes through squinting and finding the value relationships of figure to ground. One last area needs to be explored—organizing the areas of value in a format. It was Caravaggio in the early seventeenth century who first discovered the tremendous organizing power of lights and darks. Since all one can draw on a two-dimensional paper is a series of two-dimensional shapes, composition, or arrangement of these shapes, is essential to creating a coherent, pleasing and finished work.

The idea of effective visual organization is not new to any of us. Landscaping a front yard is not the same as planting a garden. The garden is organized intellectually, not visually. The front yard is organized visually, using larger and smaller shapes of different texture and color, designed to lead the visitor to the front door. Organizing the shapes of value in a drawing is exactly the same (but you don't have to wait for it to grow). As with a yard, you begin with a bounded space. In drawing, that bounded space is called a format. Within this space, as with the yard, you organize shapes. In a drawing you, instead of the front door, you organize these shapes to lead the viewer to the center of interest.

GOING TO CHURCH
Conté and colored pencil on vellum bristol
13" x 18" (33cm x 46cm)

Why create value patterns?

What is Composition?

Composition is simply the arrangement of shapes of value within a format. Is there a formula? Thank goodness there is not.

Things to do:

1. Create a pattern that leads to your center of interest.

2. Choose a pattern that has variety in width and edge quality.

3. Select a pattern that divides the format into interesting shapes.

Things to avoid:

1. A boring division of space

2. Too many hard edges that detract from the center of interest

3. A pattern that is too predictable in its width. Remember, the number of possible arrangements of values within a format is literally endless.

Call me old-fashioned, but I find organization more appealing than chaos, harmony more pleasing than discord, and design more enjoyable than confusion.

Beautiful music is not created by playing random notes beautifully. It's creation consists of notes put together in beautiful patterns, organized and played masterfully. I believe the same applies to drawing.

It's All About the Organization

In the first format below, the three values are scattered randomly around the space with no perceptible order. Your eye bounces all over seeking a place to land, but finds none. The arrangement is the same as one created with an explosion. If you look at this for a long time and it begins to feel uncomfortable, go outside and get some fresh air.

The three values in the second format have been grouped together, but in a boring arrangement. Each is segregated from the other, and the black is too far away from the white to create any contrast.

On the far right, in the third format, we find the values are also grouped together; that is, all the grays connect, all the whites connect, and the darks are accents in one area. However, in this arrangement below the three values interconnect. The lights push up into the grays and the grays push downward into the lights. The darks are grouped for maximum effect to create a center of interest, one area that is more important than all the rest. Squint at the design, and you will be able to see the two mega-shapes of gray and light that form the foundation for the composition.

The Difference a Pattern Makes
These three formats each have about the same amount of middle gray, white and black. Which of the three is the most interesting and pleasing to you?

Some of the Limitless Possibilities

Here are some possible value patterns. Each has a large pattern of mid-value gray and a small area of concentrated lights and darks. There are many variables. The gray pattern can touch one, two, three or all four sides of the box. It can be wide or skinny anywhere in the format. There is no end to the possibilities.

The one standard that applies to all of them is the gray values connect into a single large pattern. Each shape of white either touches another light shape or is close enough to connect visually. A dark shape is either connected to the next dark shape or is close enough to be seen as connecting behind the light shapes. Think of them as families. Don't break them up!

Composition with value patterns

A single object placed in a format does not make a composition. To compose means to arrange within a space, and you can't arrange one thing by itself.

Try to think more about what the pattern of darks is doing rather than what the object represents.

In other words, how are the darks moving through the format? What edges do they touch? How much of an edge do they embrace? Does their direction complement the direction of the subject instead of echoing it? Squint to see the patterns of value.

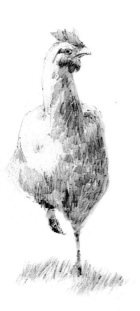

The Value of a Value Pattern
This little chicken has been placed in a format slightly off-center to the left. However, she's lost in the space and looks isolated and disoriented. A value pattern does several things: It gives the chicken a place to live instead of floating in nothingness, and it breaks up the format space, making it more dynamic.

Adding the Pattern
I began by adding darks next to the light of the neck, thinking of the head as the center of interest. I had no plan in mind except defining the light with dark. I then carried the dark over to the left edge of the format and decided to continue behind the head (but not around it—a black halo). I had envisioned a large dark shape behind the chicken's head gradually becoming gray as it reached the right side of the format. I don't know what happened. No one was there to stop me and the dark shape took on a life of its own and became boards and grass. What I ended up with was a value reversal drawing. I may have gone a little bit overboard, but the drawing is still much more dynamic than the one of the poor chicken lost in space. In this version, the pattern of darker values moves across the top of the format, down the left side, into the bottom of the chicken and down into the grass at her feet.

Patterns Define Features and Create Environments

In this drawing, I placed the head slightly up and centered it between the two sides of the format. I hoped to shift the weight to the right by highlighting the left side of his face (his left side) and subduing the detail in the right side.

Do you see how the value pattern performs several functions here? It defines the features, provides a living environment for the head and activates the format with a dynamic push-pull between the lights and darks. Turning the drawing upside down helps you to see the shapes of value not as things, but as flat shapes arranged in the format.

See Value, Not Objects

In the previous two drawings, the dark value pattern existed primarily in the background shapes supporting and defining the figure. In this drawing, the dark pattern exists inside the subject as well as in the background. Value patterns exist separately. A dark or light value pattern can be part figure, part ground.

Value patterns in landscapes

I mostly work with subjects that have some good possibilities, not a perfect, complete pattern: a nice light shape against a dark, a good dark shape against a light, the beginnings of a great pattern of middle darks or a good combination of light and dark shapes amid a great deal of visual clutter. Most of the time, the subject presents more shapes and areas of contrast than I need, so I simplify.

The following are three subject photos and the value pattern drawings done from them. If you turn the book upside down and squint at the subjects and the drawings, you will see the pattern that was taken from each of the photos. I usually begin with the center of interest and work out to the edges—I don't get involved in things that don't contribute to the overall pattern. I often hear the question, "How do you know what to leave out?" The answer is, "I leave out everything that doesn't contribute to the major pattern." If I can see a good possible pattern, then I can visualize the finished drawing.

Light Against Dark
This is a good example of a pattern of light shapes against a pattern of darker values.

Only Keep What's Necessary
This pattern is the essential information from the photo of the shoppers. Your intellect would focus on explaining each item and would miss the overall patterns. By looking at patterns instead of things, I am able to avoid getting caught in the signs, window dressings, etc. I use the parts of the pattern that help highlight the two light figures. I could create an effective design with even less, but more would be too much.

FROM THE ARTIST'S BRAIN
You may come across a subject with a ready-made value pattern just ripe to be copied—but don't hold your breath. If you wait for these perfect compositions to materialize, you won't have to worry about doing much artwork.

Reference Photo
This scene from the Isle of Iona in Scotland is one of those nearly perfect value patterns: a dark pattern silhouetted against the light.

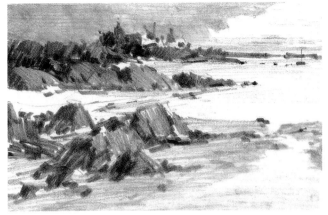

Tweaking the Value Pattern
I made a few minor changes to the photograph. I grouped all the buildings away from the edge and added gray in the sky to bring out the light pattern. I cut into the dark rock at the left edge to avoid a rectangle shape, and I left out some of the small, isolated dark rocks on the beach because they call too much attention to themselves. Look for the value pattern, then add detail to enhance the pattern or build a center of interest. Don't get this backward by beginning with the detail and trying to build a value pattern later.

Reference Photo
This pastoral scene has beautiful trees with plenty of variation in values. Look for good shapes to build on. You can then change or delete them to strengthen or detract from the main one.

The background mountain is too dark. It steals some strength from the dark tree. The mountain shape is also a little too boring, but a bigger problem is the foreground. It consists of a few disconnected pieces of darker value that do nothing for the subject. Make them work or fire them.

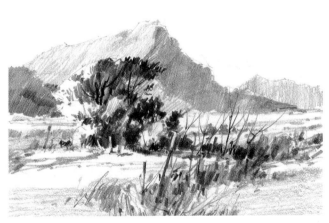

Making a Path
The most obvious change in the drawing is the connection of the mid and dark values in the foreground into a pattern which leads obliquely to the center of interest. The trees needed no changes. The highest peak was moved to the right, so it wouldn't be directly above the trees, and the far left mountain shape was cut off, so it wouldn't be as tall as the center one. Now we have a pathway of connected darks leading from the foreground back to the center of interest, and a background that helps the subject.

Simplifying the subject

More drawings and paintings fail from having too much detail than from having too little. In composing the value pattern, you will often need to simplify the subject by eliminating trivial bits of light or dark; seldom will you have to add more value shapes to your drawing. Grouping shapes of similar value into a larger "mega shape" is one of the most effective ways of simplifying a complex subject. Of course, that's after you have ruthlessly eliminated the competition.

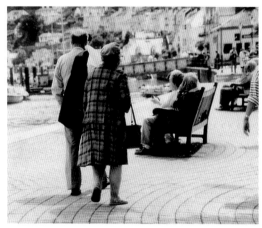

The Basic Value Pattern
This is an example of a subject with background clutter. First ask yourself, "What is this drawing about?" And then, "Is there a shared value that ties more than one shape together?" Squint at the subject to see the bigger shapes of value.

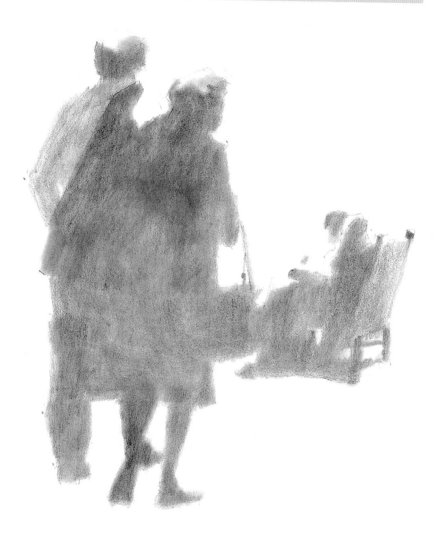

Find the Important Stuff
Start with the big picture. Decide what you want to make for dinner before dragging out spices and ingredients.

This is the value pattern you see with your eyes half closed. This big shape will tell you what else is needed in the drawing.

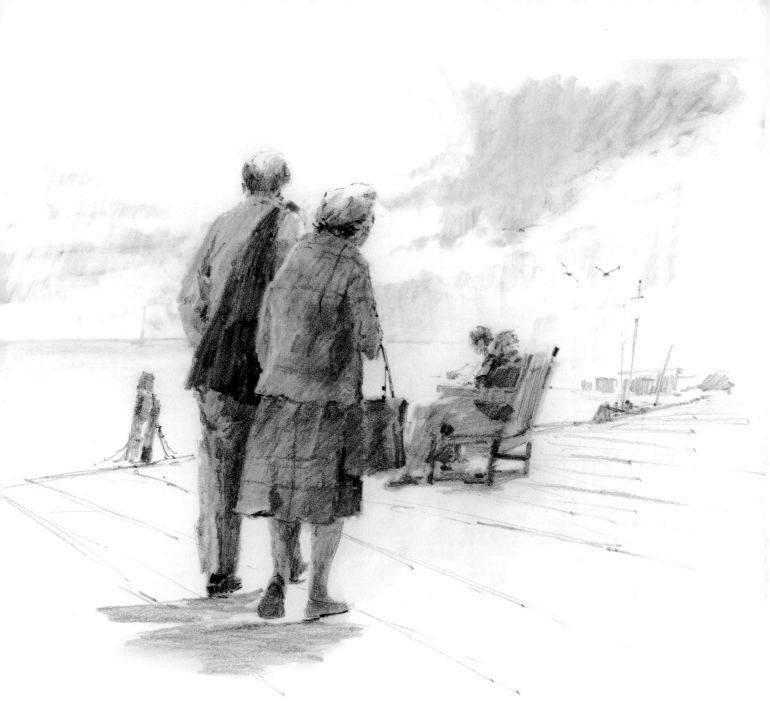

Develop the Center of Interest

After developing the center of interest, I usually find that I don't need much else to complete the drawing. This drawing is about the couple taking a stroll. Where they are strolling is of secondary importance. I found that suggesting a pier was enough.

The fancy brickwork on the walkway, while important to the city, was not important to the drawing. The city itself is important to those who live there, but not the drawing about these people. The value of the lady's suit is far more important than the fabric's plaid design. Decide the intent of the drawing at the beginning, and keep it firmly planted in your mind to the end. That way enticing details won't lure you off track.

Drawing a Complex Scene

*Have you ever avoided a complex subject like this because you felt overwhelmed?
I have! Don't let complexity keep you from enjoying a drawing activity. The only
thing that can get hurt is your ego.*

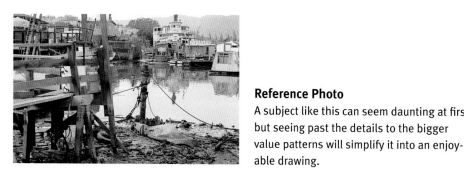

Reference Photo
A subject like this can seem daunting at first,
but seeing past the details to the bigger
value patterns will simplify it into an enjoy-
able drawing.

1 Find the Value Pattern
Squint until you only see it as divided into two basic values: all
values from middle value and darker, and all the lighter values. The
darks can be seen as a large "C" touching both sides of the format.

2 Add the Value Details
Draw the large pattern of darker values leaving the light areas
as white paper. For this big pattern, use a big tool: a carpenter's
pencil or a stick of graphite rather than the small tip of a pencil.
Using a larger tool to lay in the pattern also discourages the ten-
dency to pay attention to details that will lure your drawing into the
heap of failed works.

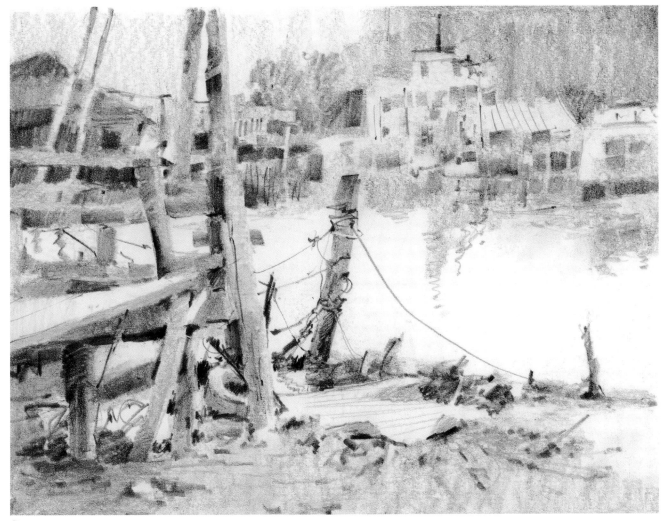

3 ▸ Develop the Center of Interest
Add darker values in the center of interest and really push the value contrasts; add some details we all love, but keep your eye on the whole.

If I had begun by defining the background, I wouldn't have known how much definition it should receive because I wouldn't have the center of interest to compare. Laying in a value pattern first, then developing a center of interest, may save the drawing.

Exercises in spotting patterns

Exercises are part of every serious discipline. Here are some exercises to develop an awareness of value patterns and the ability to react to those patterns. Practice on a regular basis, and you'll improve your ability to arrange the values in a drawing.

Exercise 1: Crop an Upside-Down Photo

Turn some photos upside down and go through them squinting. Find one that has an area in which gray, black and white are all present. Tape it to a board upside down.

Upside-Down Reference Photo
Turn the book upside down so you can see the image. Now, look at the values. Squint! The lower right quadrant has an area where all three values work together: white, gray and black shapes interlock.

Isolate the Design
Two L-shaped pieces of mat board or any stiff paper can be used to make an adjustable format. Move it around your photo until you find a design with a movement of light shapes against dark. Squint to see the pattern. Select the most interesting arrangement, and tape it in place.

Draw the Value Pattern
Draw the image from your cropped photo on a piece of drawing paper. Don't make it too large—about the size of a credit card is perfect. Use a 6B pencil to roughly draw the grays and blacks, leaving the white space. Don't duplicate the photo—respond only to the value patterns. The photo is a springboard. This exercise will give you some great ideas for compositions you may not think of otherwise.

POINTS TO REMEMBER

⋯⋯> You can create movement through your drawing by arranging shapes of similar value into a pattern.

⋯⋯> Many shapes of different values placed haphazardly throughout a drawing create visual chaos.

⋯⋯> Composition is the arrangement of shapes of value in a format.

⋯⋯> Simplify the values in your reference to form more effective patterns.

⋯⋯> Value contrast creates a center of interest.

⋯⋯> Look for underlying value patterns in seemingly complex subjects and respond to those first.

⋯⋯> You will become more "pattern conscious" with practice.

Exercise 2: Bridging

One of the goals of composition is to direct the viewer's eyes around the format to stop them where you want. You encourage movement with shapes of similar value, and you bring it to a stop with value contrast. Our eyes stop at the boundaries caused by a sudden contrast of value. "Bridging" is the concept of creating eye movement from one side of the format to the other via a "bridge" similar in value shapes. The idea is to create various shapes that touch or nearly touch continuing to the other side of the paper. Vary the shapes to keep it interesting. Don't define the edges of your pattern—leave them a little sketchy. Leave light areas where the two lines cross for a center of interest.

Bridging: It's as Easy as 1-2-3

Draw a rectangular format and divide it horizontally somewhere above the center with a light line, then again vertically to the right of center. Where they cross is a good spot for the center of interest. Begin developing a pattern of middle darks as in 1. Rectangle 2 shows the completed bridge, and 3 shows the addition of the vertical bridge. Create as much variety as possible and think about leaving some lights for a center of interest.

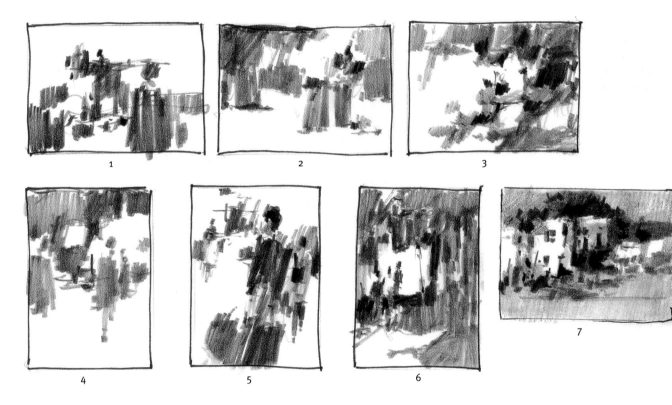

More Bridging Challenges

Provide yourself with challenges to solve in bridging from side to side and top to bottom. Here are some examples of such challenges.

1. Touch the bottom twice and each of the sides, but avoid the top.
2. Touch the top and two sides, but avoid the bottom.
3. Touch all across the top, down the side and part way across the bottom. Move into the central area and create a center of interest.
4. Touch each side at least twice and come almost to the bottom.
5. Begin a bold diagonal at the bottom that moves to the right, then shifts to the left.
6. Isolate a light shape and push a dark shape into it.
7. Lay gray over the entire area, leaving a pattern of light shapes across the format.
8. Punch up a center of interest with darks.

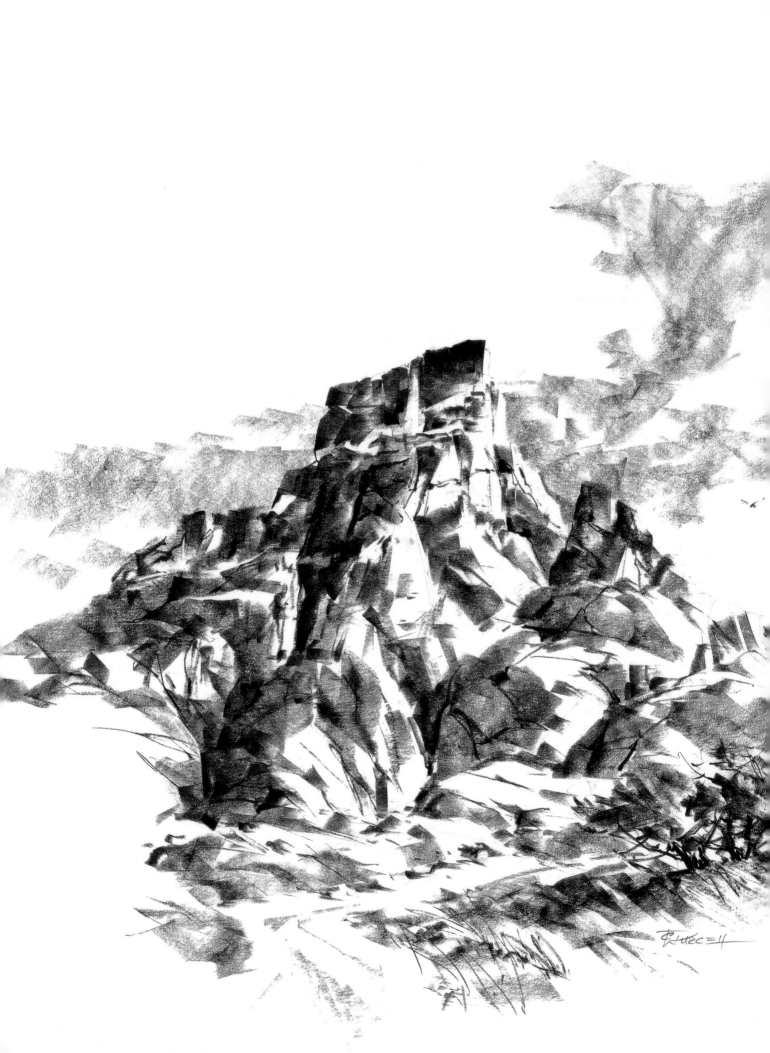

CHAPTER 7

keeping a sketchbook as
YOUR PERSONAL RECORD

When I was a student, I thought the purpose of drawing was to record what I saw. My camera could record so much more quickly and accurately. I thought there was no need to do a lot of drawing. Boy, did I miss the boat! Drawing gives birth to art. Drawing is the means by which the invisible is made visible. Through it, your personal response to the visual world is brought to the surface.

I recently thought I had lost a sketchbook that I had filled with drawings during a trip to the British Isles. I would rather have lost some paintings than that book. I would gladly have traded all of my photos for just a few pages. What a relief when I finally found it! Each drawing was a record of my response to what I had seen.

I like my camera. I have found it to be a very useful tool. But it is only one of the tools I use and, like them all, is limited. It doesn't know what aspect of the subject really captivates me. How could it? It can only record what's there.

My sketchbook, on the other hand, receives the imprint of my personal responses to a subject. The drawings are a record of what I saw rather than the camera. In this chapter, we will explore the sketchbook as a tool and, hopefully, inspire you to use it more and more as a vital part in the way you create art.

Draw, doodle, and dream

The kind of drawings you do in your sketchbook will vary depending on the purpose. Use your sketchbook in whatever manner serves your needs. The drawings in it need never be seen, so you can finish them to whatever degree suits you. You can write in it, try new materials, or a new subject matter, even doodle or dream. The sketchbook is your private world. The following are a few of the types of drawings in my sketchbooks:

1. Drawings done to expand my understanding of forms
2. Brief visual notes that record details I want to remember or fleeting observations
3. Interesting observed shapes that might be used in future paintings.
4. Value studies that plan the distribution of lights and darks for a painting
5. Sketches that record essential information in a scene

Discover the Surface and Structure

I did this little sketch to help myself understand the structure of a boat in order to draw one with authority. If I follow the top edge of the hull all the way around, it forms a figure eight. The stem and stern are located at the highest points near the end. Lines that follow the curve of the hull, although not actually evident on the surface, are part of the ribbing inside and help me feel the bulge of the hull. Drawing becomes an extension of my eyes. I try to draw what I would feel if I ran my hand over a surface.

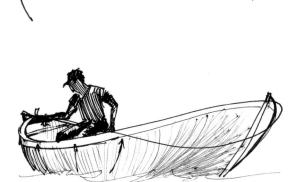

Let your Lines Grow

Try drawing a tree without using outlines or contours. Respond to the upward-reaching gesture with lines that follow the growth pattern. Move outward to the tangle of little branches using a tangle of little lines.

You may find, as I do, that a particular form is too hard to understand and cannot be drawn in the way you want. Instead, use drawing to gain understanding. Probe beyond what the eye can see to the inner structure of a form. The insights you gain will become a permanent part of your understanding—something that will be evident in the next drawing of a similar subject.

Drawing to understand form

Draw the Movement

Do a drawing from the inside out—from the skeletal structure outward to the edges. You will find that you capture the gesture and the movement better. I did this drawing to feel the action of riding a bicycle. A detail-centered, edge-conscious drawing would not give me that feeling. This drawing is not for show-and-tell. It's for me only.

Let your Lines Tumble

Nature responds to the forces of gravity and erosion. I wanted to do the same with this drawing. Each line was drawn as if it were a small rock falling off the top ledge, leaving a line to trace its descent. The lines are a record of my attempts to feel the rock bouncing off successive ledges until it reached the talus slope where it rolled to an eventual horizontal plane. This is not a copy of a particular mountain. It is a response to the rhythm of the forms: to the forces that shape these kinds of mountains.

Brief visual notes

How many times have you seen some small thing—a pile of rocks, a twig, a figure carrying a package, the sun hitting the edge of some form—and thought, "I wish I had my camera or sketchbook with me." Save these precious little moments of discovery in your own personal visual note.

Use your camera to record fleeting images or intricate details. But if you want to understand what you see, draw it. You will put it into your stew of visual knowledge, and everything drawn makes the stew richer. Using only you camera is like having the seasonings but never putting them in the pot.

FROM THE ARTIST'S BRAIN

Use your camera to record fleeting images or intricate details. But if you want to understand what you see, draw it. You will put it into your stew of visual knowledge, and everything drawn makes the stew richer. Using only your camera is like having the seasonings but never putting them in the pot.

Draw what you Discover
Even if I never use these two sketches in a painting, by drawing them, I gain something that I wouldn't have had I used a camera.

Whenever I need a figure for a painting, I can find one in my sketchbooks. Practicing quick studies of people on the street is an excellent exercise in fast notation. It makes you look long, and sketch short. Watch a person walking and notice what the shadows on the legs do as one leg goes forward and the other moves back. How does the shadow describe the calf muscle? What shape do you see as the foot bends against the pavement? Then, quickly sketch the basic shapes, add what you noticed of the shadows, and complete it from memory. At first this will be difficult, but with practice, you will get better and faster.

Three Shapes

See the figure as three shapes: head, torso and pelvis, with extensions into space for the arms and legs. The torso shape is basically a shirt or jacket and the pelvic area might be a skirt, shorts or bulky pants. I quickly get the basic shapes down and take note of shadow patterns at the same time. Then, if the figure is gone, I can look around to see someone else moving in a similar direction to help me with the legs or arm patterns.

Interesting shapes saved for later use

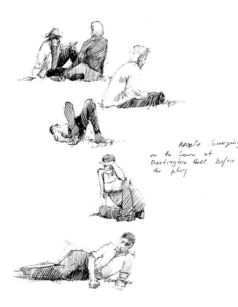

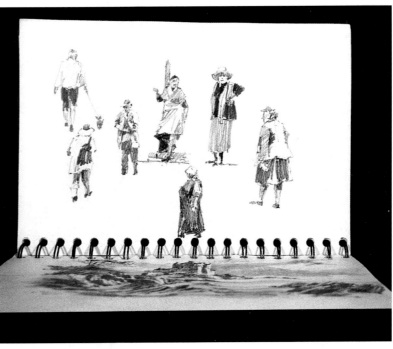

Look Long, Sketch Short

We were in England waiting for the start of an outdoor theatre production. People were lounging on the grass. They stayed in their positions long enough for me to get these studies with a ballpoint pen.

Note the Basic Shapes

These were moving quickly past, so instead of pen, I used a 6B pencil. The emphasis is on getting the essential shapes and value down as quickly as possible. Look for variety: tall thin shapes, wider shapes, backpack shapes, anything that will make the figure interesting and keep you from drawing the same one.

Value studies to prepare for a painting

Often I find an appealing subject that needs some redistribution of lights and darks. If I am painting on location, I don't need to do a completed drawing because the details will remain in front of me. All I need is a plan for the values. These I do in my sketchbook. I am a watercolorist, so I have to know before I begin where to leave white paper.

Don't Wait for Film
I also took this photo of the subject, but it didn't help me at the time for the on-site painting.

Draw What You Want to See
In this quick value study, you can see that I have made a few changes. I increased the distance between the background and the foreground to make a better light shape and more of a break in the line where dark meets light. I invented a pattern of darks in the foreground to lead into the subject, and I decreased the size and interest of the dark shape at the right. This takes only a few minutes but is worth every second.

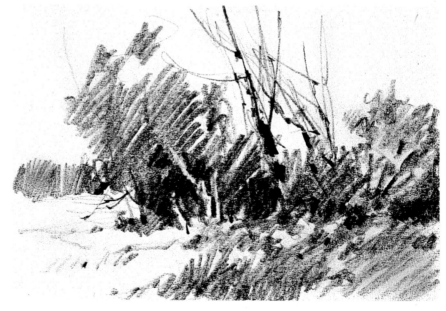

The camera records too much. You want to record a particular area of interest, but the camera can't tell what you have in mind and so records everything. It's like asking someone for directions to the theater and getting a history of the building. I have taken many photos and later could not for the life of me figure out why I took them. Everything is in the photo except that certain something, whatever it was, that inspired me in the first place. On the other hand, I have never looked at a drawing and wondered why I did it. That's why a sketchbook is more valuable than a camera. In my sketchbook, I start with what captured my attention and work outward. I don't waste time on what doesn't help that pivotal idea. Most of what my camera records never makes it into a drawing.

Collecting the essence of a scene

Combine Elements as You Need

We spent a week here at the Clifden Castle gatehouse cottage in Ireland. There were a number of standing stones nearby, but not quite this close to the cottage. A photo could not have combined them as I have done here. I started with the cottage and castle gate, added the standing stone and then decided how much road and grass I needed to complete the idea.

Build a Reference

My wife and I hiked up to the Falls of Bruar in Scotland. It was a nice day, but the thick vegetation and narrow glen shut out most of the light. The photos I took were not worth keeping. In this sketch, I began with the bridge and worked downward. When I look at the drawing, I can hear the roar of the stream. Everything comes back to me. I could build a painting on this drawing with no other reference.

Take it with you

I have found that for me, a 6B graphite pencil and the broad-stroke technique described on page 78 are the most useful tools for gathering information for paintings. Drawings done in this manner occupy the bulk of my sketchbooks. Here are just a few of these drawings. I share them with you in the hope that they may inspire you to take your sketchbook along on your next trip and use it every day.

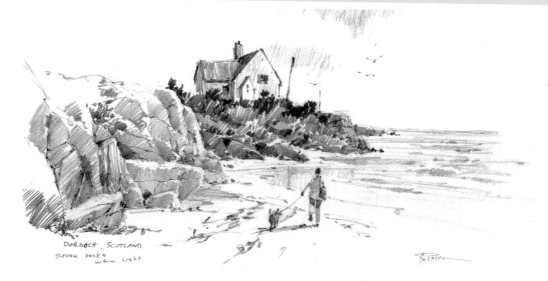

On the beach at Dornoch, Scotland

Home in the Scottish Highlands

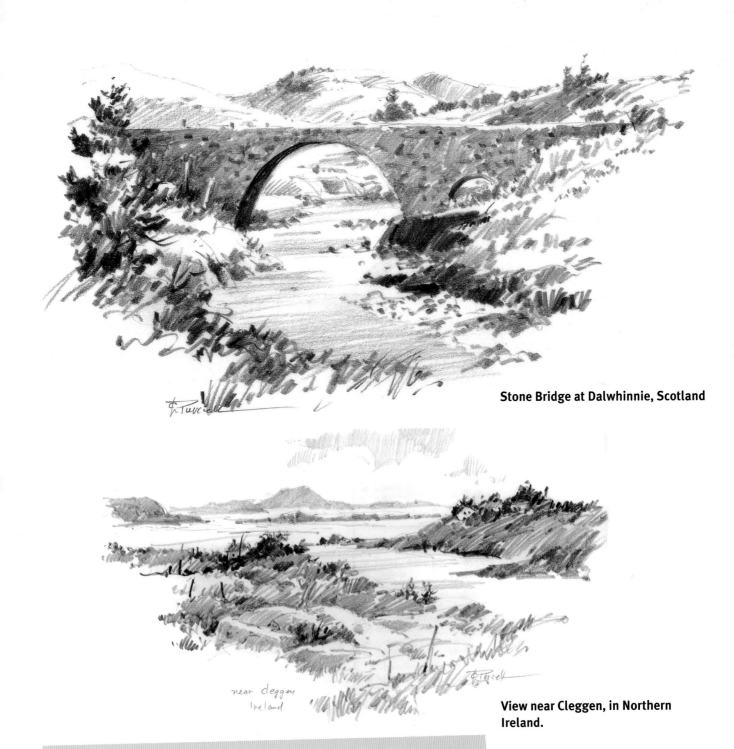

Stone Bridge at Dalwhinnie, Scotland

near cleggan
Ireland

View near Cleggen, in Northern Ireland.

POINTS TO REMEMBER

⤍ Your camera cannot record how you feel about the subject. Create the sketchbook habit.

⤍ Use your sketchbook to expand your knowledge and understanding of things around you.

⤍ Your visual mind is like a savory stew. Drawing is the only way to add ingredients.

⤍ The camera records too much. Your sketch records record only what is important to you.

⤍ Know your intent. What do you want to gain from this drawing? What do you want to say with the drawing?

⤍ Picture the subject as a drawing, then draw!

A portfolio of drawings

There are several things that influence the outcome of any drawing I do. The first is the subject. I look at the subject and imagine it as a drawing. The subject usually influences my choice of medium, which influences the way I picture the drawing. I draw differently with the broad edge of a Conté stick than I do with a pencil—I have to.

The second is my intent. Am I recording a subject for future use? Am I doing a completed drawing or portrait of how I see the subject? Or, am I exploring the possibilities of a subject's visual elements? The drawings that follow are of different subjects, all done with different media and different intentions.

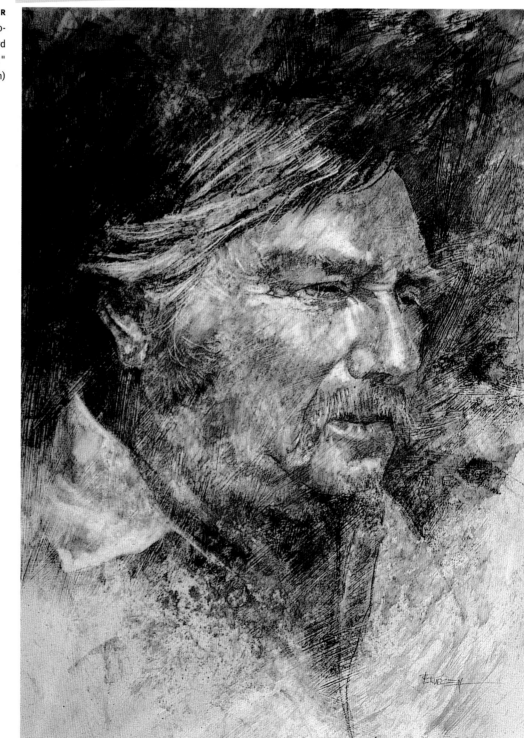

WELSH SLATE MINER
Nupastel on gesso-treated mat board
19" x 13.5"
(48cm x 34cm)

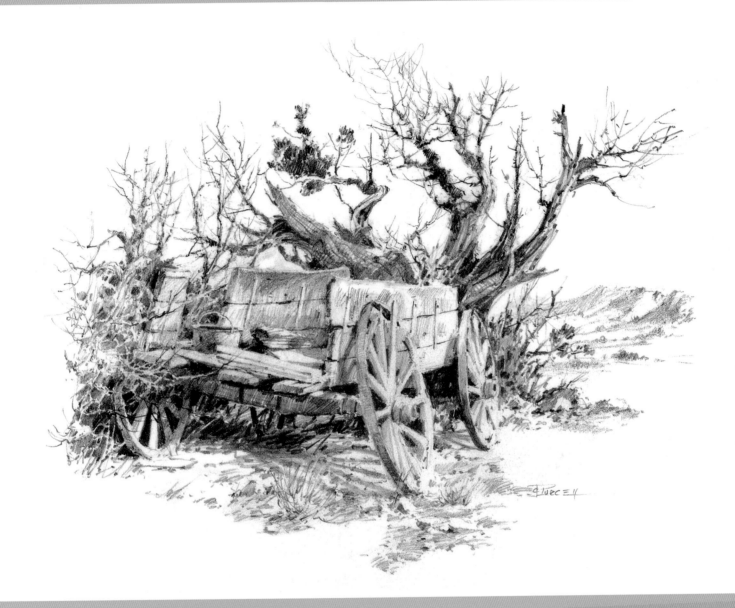

OLD FRIENDS
Graphite on bristol paper
8.5" x 10" (22cm x 25cm)

KENMORE, SCOTLAND
Graphite pencil on bristol paper
8" x 10" (20cm x 25cm)

ALMA AT THE BULLETIN BOARD
2B Conté on bristol paper
20" x 12" (51cm x 30cm)

GOTHIC ÉTUDE
2B Conté on paper
19" x 12" (48cm x 30cm)

GATEHOUSE AT ARDVERIKIE ESTATE
2B Conté on bristol paper
14" x 15" (36cm x 38cm)

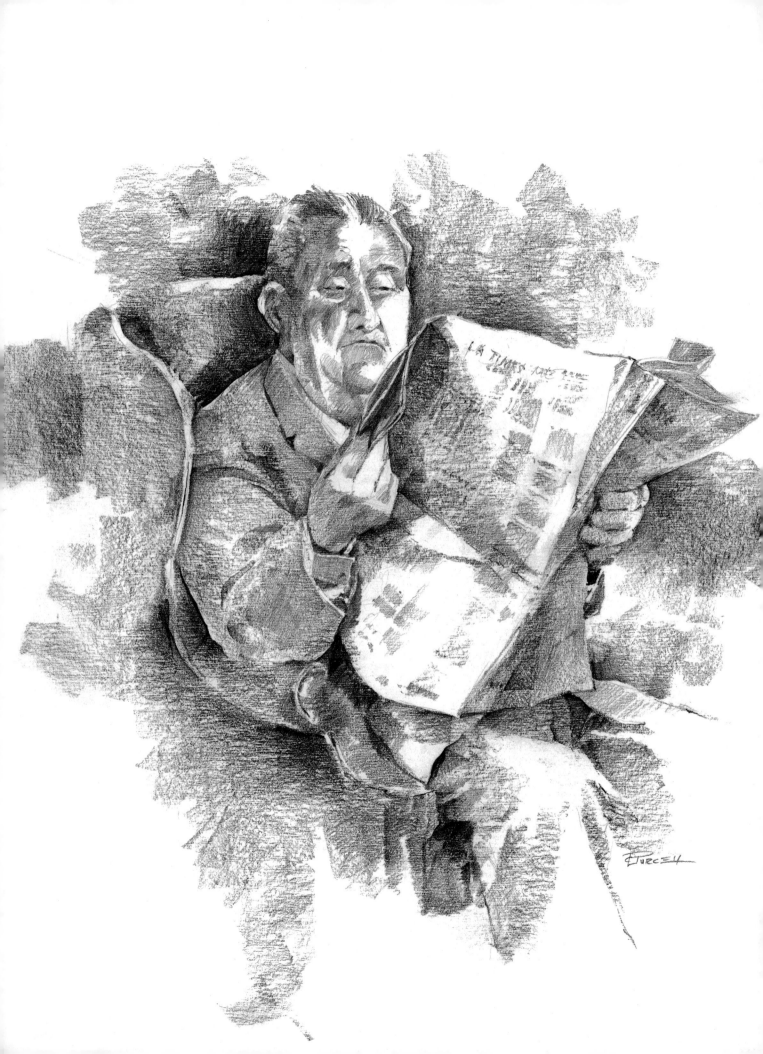

Conclusion

Drawing remains the most universal of all art forms. It underpins every discipline, from architecture to automotive design, sculpture to painting. With this book, I've hardly scratched the surface of the ways drawing can be your ticket to visual discovery. As Frederick Frank put it, "Drawing is the discipline by which I constantly re-discover the world." For me, drawing is the means by which I also re-discover myself. Through it, I find a means of connecting to something greater, and I realize that I'm only a small part of a larger divine creative action.

I hope this book has given you some tools for your own artistic journey. My emphasis has been on accessing the abilities of your non-verbal, visual brain in the drawing process. I encourage you to persist until seeing spatial relationships of angle, size and position becomes habit. Eventually, drawing will become more than a laborious means of copying, it will become an extension of your mind. You'll use drawing to penetrate forms and gain an elevated understanding of the world around you. One cannot conduct the kind of search drawing requires and come away with nothing. Not only will your work be a record, but a self-portrait. I wish you Godspeed in the pursuit of your own creative possibilities.

THE MORNING NEWS
Graphite on foamcore board
12" x 16" inches (30cm x 41cm)

The best in drawing instruction comes from North Light Books!

Discover new ways of working that free your creativity! Every artist wants to be more creative, and this book demystifies that often confusing process. There are over forty exercises to help you unlock the power of the imagination and learn how to recycle old drawings into fresh ideas.

With fun exercises, expert instruction and a gallery of inspiring examples, artists of all levels will come away more confident and creative!

ISBN-13: 978-1-58180-757-8; ISBN-10: 1-58180-757-0; HARDCOVER, 192 PAGES, #33424

The Artist's Guide to Drawing Realistic Animals is the perfect book for anyone who wants comprehensive, illustrated instruction for drawing his or her favorite domestic and wild mammals and birds. Wildlife illustration expert Doug Lindstrand provides step-by-step guidance on capturing everything from cats, wolves, and deer, to elephants, polar bears, and eagles—all in a variety of accurate and classic poses. Readers will learn time-honored drawing techniques they can use not only to create lifelike animals but also as a foundation for future art projects.

ISBN-13: 978-1-58180-728-8; ISBN-10: 1-58180-728-7; PAPERBACK, 144 PAGES, #33400

Take a weekend to develop a lifetime passion! Perfect for beginners and leisure artists, this book guides you from the most basic shapes and objects through to fully developed and varied projects. Inside you will find encouraging advice and instruction for a variety of drawing media, including:

- Graphite pencils
- Colored pencils
- Conte
- Pastel
- Charcoal
- And more!

ISBN-13: 978-0-7153-2424-0; ISBN-10: 0-7153-2424-1; PAPERBACK, 128 PAGES, #41898

Absolute beginners and those looking for a refresher course will find this book to be a wonderful tool. The authors, Mark and Mary Willenbrink, have created a series of exercises which take you from the basic fundamentals of drawing to the complexities of creating landscapes, still lifes, people and much more. With encouraging words and an emphasis on having fun, each exercise is designed to build confidence. Complicated concepts are explained in a clear, understandable manner so that even the novice artist will feel inspired to try. Before long, you will find yourself drawing with a confidence you never imagined!

ISBN-13: 978-1-58180-789-9; ISBN-10: 1-58180-789-9; PAPERBACK, 128 PAGES, #33465

These books and other fine North Light titles are available at your local fine art retailer or bookstore or from online suppliers.